Bjørn Melhus

Bjørn Melhus

DU BIST NICHT ALLEIN
YOU ARE NOT ALONE

herausgegeben von / edited by
Bernd Schulz

mit Beiträgen von /
with contributions by

Katja Blomberg
Joachim Kalka
Bjørn Melhus
Werner Meyer
& Bernd Schulz

Kehrer Verlag Heidelberg

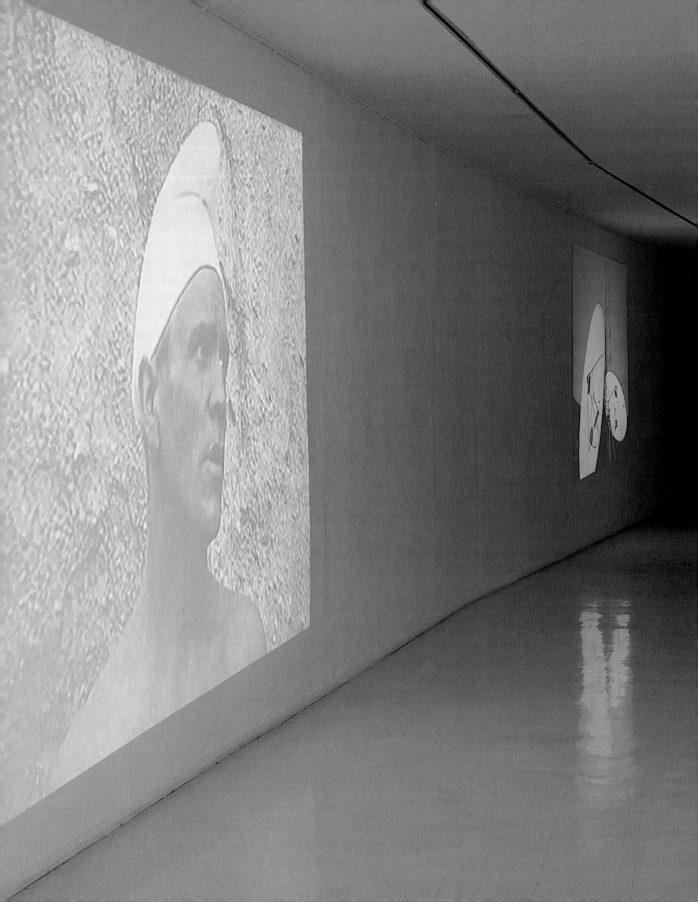

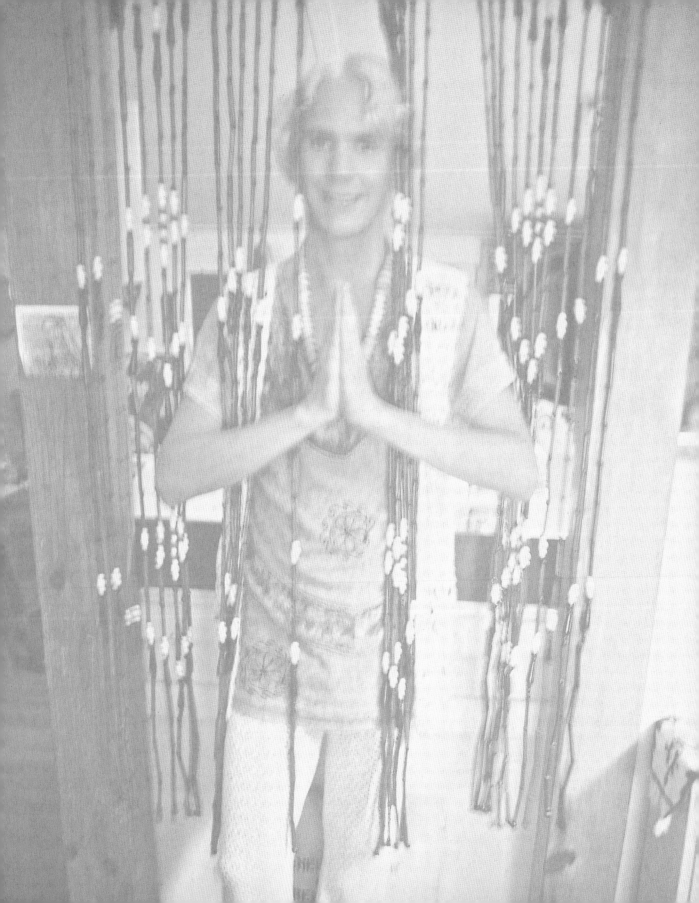

VORWORT

Dieses Buch über Bjørn Melhus macht auf einen Videokünstler aufmerksam, der nicht nur souverän Filmsprache und digitale Bildtechnik beherrscht, sondern mit dem Thema des Zwillings oder Doppelgängers einen Weg gefunden hat, die aktuellsten Themen unserer Zeit miteinander zu verbinden: die Horrorvision vom Klonen des Menschen und die Frage nach der Behauptung eines identischen Ichs im Zeitalter rasch wechselnder kultureller Identitäten und ihrer medialen Spiegelungen.

Bjørn Melhus, der sich mit den Bild- und Klangwelten der Popkultur auf scheinbar leichte und spielerische Weise auseinander setzt, hat sich die Produktionstechniken des Films und des Fernsehens angeeignet und treibt, wie die auf dem Filmset entstandenen Fotos zeigen, den Aufwand professioneller Studioproduktionen, um das Ausgangsmaterial zu seinen digitalen Bildwelten zu erhalten. »Sparsam« ist er nur bei der Besetzung der verschiedenen Rollen. Er spielt alle Rollen selbst und verkörpert damit eine Spaltung, mit der wir alle, wenn wir uns ehrlich fragen, wer wir eigentlich sind, zu schaffen haben. Wo verläuft die Grenze zwischen dem Ich und dem Du? Auf welchen Gefühlsfolien und vor welchen Bildhorizonten unseres Inneren agieren wir? Welche Handlungs- und Erfahrungsmuster sind in uns wirksam, seit auch die Kindheit angeschlossen ist an die kommerziellen Film- und Fernsehwelten? Was sind das für Projektionsflächen, die uns da entgegenkommen? Werden wir manipuliert oder manipulieren wir uns selbst?

Bjørn Melhus scheint sich die Analyse, die im konsum- und mediensüchtigen Menschen ubiquitäre Agenten der Selbstzufriedenheit sieht, als Plattform für seine ausgefeilten Bildproduktionen angeeignet zu haben. Es gibt keine Identitäten mehr, sondern nur noch unendliche Spiegelungen, deren Formen und Inhalte aus vorhergehenden medialen Spiegelungen stammen. Es ist vor allem die Fernseh- und Kinowelt der 60er Jahre, die in seinen Videoarbeiten auf raffinierte Weise beschworen wird, eine Welt, die unsere Gefühls- und Sprachformen mehr geprägt hat, als wir wahrhaben wollen. Bjørn Melhus scheint die Bruchstücke aus dem Unterbewusstsein hervorzuholen und zu untersuchen wie ein neugieriges Kind das Sägemehlinnere seines Teddybärs. Die großen Gefühle, so zeigen diese Arbeiten, wurden gestaltet, lange bevor sie erlebt werden konnten, und es scheint, als wä-

ren die freundlichen Zombies, die diese Videos bevölkern, auf der Suche nach einer Kindheit, die sie nicht wirklich erleben durften.

»Wir leben heute in einer ganz neuen Ordnung, und die Verflechtung der Umstände umhüllt unsere Körper – umströmt unsere Körper mit einem Strahlenkranz der Freude.« So heißt es in dem Roman *Elementarteilchen* von Michel Houellebecq, einem Buch, das in den letzten Monaten als literarisches Zeitbild schlechthin diskutiert wurde. Es beschreibt die kalte Einsamkeit zweier Brüder und die Horrorvision vom geklonten und geschlechtslosen Menschen als mächtige Zielvorstellung in unserer Kultur. Houellebecqs Welt ist kalt, zynisch und letztlich hoffnungslos. In den Welten von Bjørn Melhus darf gelacht werden. Das ist selten im Kunstbetrieb, wo Humor gern mit mangelndem Tiefgang gleichgesetzt wird.

Der Titel »du bist nicht allein«, unter dem Bjørn Melhus seine Arbeiten der letzten zehn Jahre zusammengefasst hat, ist ein ironisches Echo auf den Slogan des TV-Gefängnisspektakels *Big Brother*. (Es ist auch der Titel eines Songs von Michael Jackson.) Der gefühlsträchtige Satz steht nun für die tragikomische Selbstbehauptung des Ichs, das auf mediale Prägungen mit ständigen Neukonstruktionen reagiert. Wir freuen uns, dass der lachende Künstlerphilosoph Bjørn Melhus Lust hatte, mit uns seine erste große Einzelausstellung zu realisieren und in diesem Buch darüber hinaus eine komplette Übersicht über seine bisherige Arbeit zu geben.

Anita Beckers, die die Originalität des Künstlers früh erkannte, danken wir für ihre Unterstützung.

Bernd Schulz
Stadtgalerie Saarbrücken

Werner Meyer
Kunsthalle Göppingen

FOREWORD

This book on Bjørn Melhus draws attention to a video artist who has not only consummately mastered film language and digital image technology, but who, with the theme of the twin or Doppelgänger, has also found a way to connect our time's most current themes: the horror vision of cloning humans and the question of the maintenance of an identity and self in the epoch of rapidly changing cultural identities and their media reflections.

Bjørn Melhus, who deals with pop culture's worlds of image and sound in a seemingly playful way, has learned the production techniques of film and television. As the photos taken on the film set show, he exerts the efforts typical of professional studio production to create the raw material for his digital image worlds. The only place he is parsimonious is in casting the various roles: he plays them all himself, thus embodying an inner division that concerns us all, if we ask ourselves honestly who we are. Where is the boundary between the I and the You? On what interior membranes of feeling and in front of what interior horizons of image do we act? What patterns of action and experience influence us, now that even childhood is plugged in to the worlds of commercial film and television? What kinds of projection surfaces confront us? Are we manipulated, or do we manipulate ourselves?

Bjørn Melhus appears to have turned the analysis that sees ubiquitous agents of complacency in people addicted to consumption and the media into a platform for his well-wrought image productions. There are no more identities, just endless reflections, whose forms and contents arise from earlier media reflections. His video works cunningly evoke the television and cinema world of the 1960s, a world that has molded our forms of feeling and speaking more than we want to admit. Bjørn Melhus seems to dredge up fragments from the inaccessible subconscious, then examine them as a curious child would sift through the sawdust filling of his teddy bear. These works show that »grand feelings« are designed long before they are experienced, and it appears as if the friendly zombies populating these videos were seeking a childhood they were not really permitted to experience.

»We live in a whole new order, and the interweaving of the circumstances encases our bodies, flows around our bodies with a halo of joy.« That's how Michel Houellebecq put it in his novel *Elementary Particles*, a book that in recent months has been discussed as a literary image of the times. It describes the cold loneliness of two brothers and the horror vision of cloned and sexless people as a powerful imagined goal in our culture. Houellebecq's world is cold, cynical, and in the end hopeless. In Bjørn Melhus' world, laughter is permitted. That is rare in the art world, where humor is often equated with lack of depth.

The title »You Are Not Alone«, which subsumes all of Bjørn Melhus' works of the last ten years, is an ironic echo of the slogan of the reality TV prison spectacle *Big Brother*. The most emotional sentence now stands for the self's laughing self-assertion that responds to media molding with constantly new constructions. We are pleased that the laughing artist-philosopher Bjørn Melhus wanted to realize his first large solo exhibition with us and, beyond that, to provide a complete overview of his work up to now in this book.

We are grateful for the support provided by Anita Beckers, who was early in recognizing the artist's originality.

BERND SCHULZ
Stadtgalerie Saarbrücken

WERNER MEYER
Kunsthalle Göppingen

Ich weiss nicht wer das ist 1991

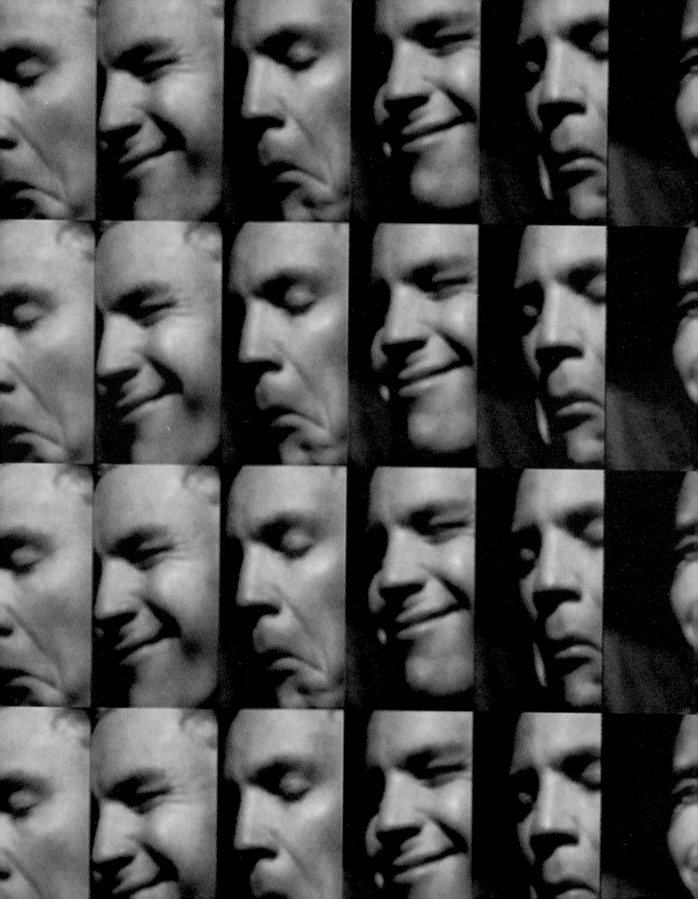

ICH WEISS NICHT WER DAS IST

I don't know who that is

Ich weiß nicht wer das ist.
Ich weiß nicht wer das ist.
Ich weiß nicht wer das ist.
Ich weiß nicht wer das ist.
Ich weiß nicht wer das ist.
Ich weiß nicht wer das ist.

Ich, ich weiß nicht wer das …

Ich weiß nicht wer …

Ich weiß nicht …

Ich, ich …

Ich, ich …

Diese Reihe von Gesichtern
zeigt nicht nur anatomische
Unterschiede, man ist geneigt, so etwas
wie Stimmungen daraus abzulesen:

Nachdenklichkeit, Unmut, Müdigkeit,
Trauer, Aufregung.
Es ist erstaunlich, wie ausdrucksvoll …

Willst du wohl still sein!
Willst du wohl still sein!
Willst du wohl still sein!

Ich weiß nicht wer das ist.
Ich weiß nicht wer das ist.

Seit etwa 20 Jahren lebt er
sozusagen unter ihnen,
und in dieser Zeit ist ihm
etwas Erstaunliches gelungen …

Beispielsweise?
Beispielsweise?

Nun … nun …

Ob er vielleicht, h…
oder ob er vielleicht, h…
oder ob er vielleicht, h…

ob er vielleicht, h…
oder ob er vielleicht, h…

… 'ne Geschlechtskrankheit hat …
… vielleicht ist er auch
nur Vegetarier geworden …

Alle Alternativen …

Ich weiß nicht wer das ist,
ich habe diesen Namen noch nie gehört!

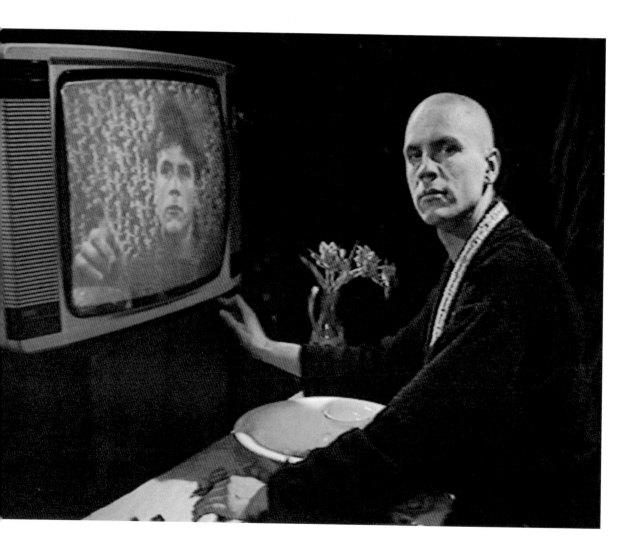

Das Zauberglas 1991

DAS ZAUBERGLAS

The Magic Glass

Ich rasiere mich.
Ich rasiere mich.
Ich rasiere mich.
Ich rasiere mich.
Ich rasiere mich.

eah?!

Komm nur, ich bin
gleich fertig damit.
Ich rasiere mich.
Ich rasiere mich.
Ich rasiere mich.
Ich rasiere mich.
Komm nur, ich bin
gleich fertig damit.

Aber warum tust du das denn?

Ich rasiere mich.
Ich rasiere mich.

Aber warum tust du das denn?
Du ziehst dir ja die ganze
Haut vom Gesicht herunter.

Oho, was!

Tut das nicht weh?

Nein, nein!
Ich rasiere mich.

Aber warum tust du das denn?
Tut das nicht weh?

Nein, nein!
Ich rasiere mich.

Aber warum tust du das denn?

Komm nur, ich bin
gleich fertig damit.

Hast du mich kommen sehn?

Ja, hierdurch!

Ist das ein Zauberglas?
Ist das ein Zauberglas?
Ist das ein Zauberglas?
Darin sieht man sich
besser als in einer Wasserpfütze.

Willst du es haben?

Tut das nicht weh?

Nein, nein!

Darin sieht man sich
besser als in einer Wasserpfütze.

So oft du hineinsiehst, wird es dir verraten,
wie wunderschön du bist.

Ja, jetzt kann ich dich auch sehn.
Ist das ein Zauberglas?
Ja, jetzt kann ich dich auch sehn.

So oft du hineinsiehst, wird es dir verraten,
wie wunderschön du bist.

Ja, jetzt kann ich dich auch sehn.

Ja, hierdurch!

Ja, jetzt kann ich dich auch sehn.

Ja, hierdurch!

Ja, jetzt kann ich dich auch sehn.

Ja, hierdurch!

Vielleicht kann man
uns beide hier sehn.

Wo?

Dort!

Mhmm, ich verstehe.

Ich, ich, ich, ich,
ich muß jetzt auch gehn,
ich muß Wacholderbeeren pflücken.

Geh nicht weg, bleib bitte!
Geh nicht weg, bleib bitte!

Das darf ich nicht.
Ich hätte sofort weggehen müssen.

Wieso?
Geh nicht weg!
Geh nicht weg!
Geh nicht weg!
Geh nicht weg!
Geh nicht weg!
Geh nicht weg!
Bleib!

Ich hätte sofort weggehen müssen.

Wieso?

Ich muß Wacholderbeeren
pflücken. (...)

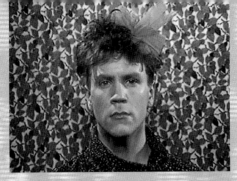

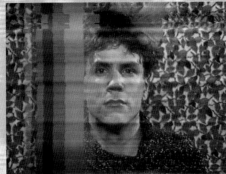

Das Zauberglas 1991 17

DAS ZAUBERGLAS – WEIT WEIT WEG

Obwohl in einem zeitlichen Abstand von rund vier Jahren entstanden, kombiniert Bjørn Melhus die beiden Arbeiten miteinander, da zwischen ihnen ein innerer Zusammenhang besteht. In erzählerischer Form behandelt Melhus hier sein zentrales Thema vom Verlust der Subjektivität durch die Welt der technischen Bilder und die Frage nach deren Bedeutung für die Neukonstruktionen der Identität. Das Drama der Ich-Findung (das zugleich auch immer eine Entdeckung des Anderen ist) ist immer auch ein Drama der Auseinandersetzung zwischen weiblichen und männlichen Rollen und den Übergängen zwischen diesen Identifikationsformen.

Ausgehend von einem Dialog aus dem Western *Der gebrochene Pfeil* mit James Stewart findet Bjørn Melhus in dem Video »Das Zauberglas«, 1991, zu einem Bild von fundamentaler Einsamkeit in der Befragung des eigenen Spiegelbildes und der Sehnsucht nach der Vereinigung des eigenen Selbst mit dem weiblichen Alter Ego. In »Weit Weit Weg«, 1995, geht es um das uralte Thema des Erwachsenwerdens, das hier als eine Art Fluchtversuch aus dem Kinderzimmer inszeniert wird. Das Mädchen Dorothy – die O-Ton-Vorlage stammt aus dem Film *The Wizard of Oz* mit Judy Garland – versucht, sich mittels eines Handys eine Doppelgängerin zu schaffen und diese zu sich zu holen. Doch die in der Phantasie gespiegelte Dorothy beginnt, ein Eigenleben zu führen, und will eine Agentin der großen, weiten Welt werden, die immer wieder in Form von Fernsehsendungen erscheint. Das Kinderzimmer wird zum Ende hin immer enger, das Spiegelbild emanzipiert sich von seinem »Original« und entwickelt narzisstische männliche Züge. Die medialen Bilder erweisen sich als Projektionsfläche und Kontrollmechanismus zugleich.

Während das Video »Das Zauberglas« die komprimierte Form eines Bildgedichtes hat, entfaltet sich in »Weit Weit Weg« die Geschichte mit Dorothy in einem ruhigen Erzählrhythmus über eine längere Zeit. Über drei Monitore schafft Melhus bewusst eine Verräumlichung. Der Betrachter / Hörer kann an den jeweiligen Stationen mit Kopfhörer in die Geschichte einsteigen und – da sie zeitlich versetzt an den einzelnen Stationen läuft – Wahrnehmung und Erinnerung gestalten und damit seine eigene Erzählung bilden.

THE MAGIC GLASS – FAR FAR AWAY

Although four years lay between the creation of these two works, Bjørn Melhus combines them, since there is an inner connection between them. Here, Melhus treats in narrative form his central theme of the loss of subjectivity due to the world of technological images and addresses the question of their meaning for the new constructions of identity. The drama of finding the I (which is always a discovery of the other at the same time) is also always a drama of the interaction between female and male roles and the transitions between these forms of identification.

Starting with a dialogue from the Western movie *Broken Arrow*, with James Stewart, Bjørn Melhus finds his way in the video »Das Zauberglas«, 1991, to an image of fundamental solitude in questioning his own mirror image and in the longing to unite himself with his female alter ego. »Weit Weit Weg«, 1995, is concerned with the ancient theme of growing up, which is staged as a kind of attempted escape from the children's room. The girl Dorothy – the original sound on tape comes from the film *The Wizard of Oz*, with Judy Garland – uses a cell phone to try to create and to bring to herself a double. But the Dorothy mirrored in imagination begins to live her own life and wants to become an agent of the greater world that appears again and again in the form of television broadcasts. In the end, the children's room grows ever narrower, and the mirror image emancipates itself from its »original«, developing narcissistic male traits. The media images prove to be projection surfaces and control mechanisms at the same time.

While the video »Das Zauberglas« has the condensed form of an image poem, »Weit Weit Weg« unfolds the story with Dorothy in a calm narrative rhythm over a longer period. Using three monitors, Melhus consciously creates a spatialization. With headphones, the viewer / listener can enter the story at the various stations and, since the various stations are not synchronized but staggered, he can shape his perception and memory and thus create his own story.

BERND SCHULZ

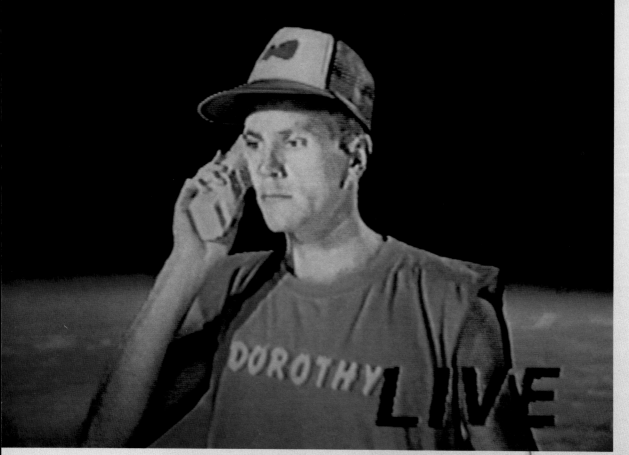

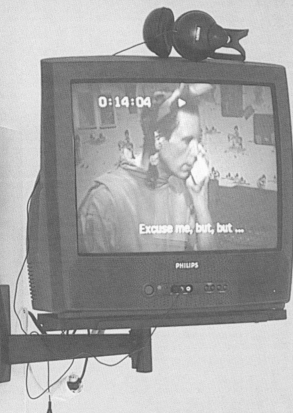

Weit Weit Weg 1995 (Installation Stadtgalerie Saarbrücken 2001)

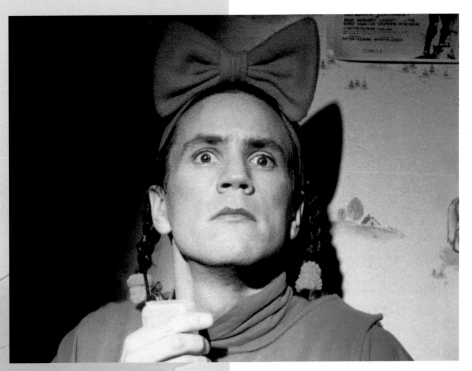

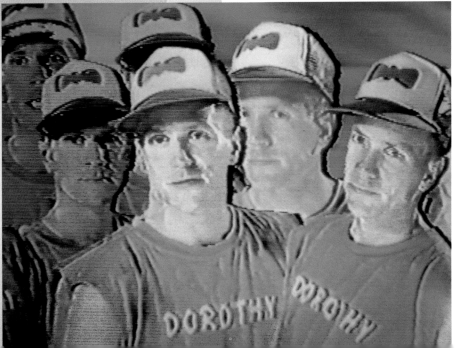

Weit Weit Weg (Auszug aus Storyboard /Excerpt from the storyboard 1994)

Weit Weit Weg (Auszug aus Storyboard / Excerpt from the storyboard 1994)

NO SUNSHINE

Bjørn Melhus gehört zu der ersten Generation, die mit dem Medium Fernsehen aufgewachsen ist, der dieses Medium wie kein anderes Vorbilder und Identifikationsmuster als Modelle für Realität und Traumwelten geliefert hat. Seine Arbeit als Künstler hat in großen Teilen eine Spurensuche in dieser Bilderwelt als Ausgangsinteresse. Das Tonbandgerät für die Popmusik und später die Aufnahme auf Video für Filme bedeuten eine unmittelbare Reflexion im Sinne des Wiedersehens, eines ausgewählten, leicht zugänglichen Archivs, mittels dessen diese Erinnerungen und die eingeprägten Bilder verfügbar werden. Die künstlerische Verarbeitung dieser Bildwelten durch Bjørn Melhus hat diese Identifikationsmuster als Erinnerungsbruchstücke zum Thema, die sich zu aktuellen Geschichten des Erwachsenen neu formieren, sich einblenden in die Frage nach dem eigenen Ich, in das Bild, das der Künstler sich buchstäblich von sich selbst macht, wohl wissend, dass auch dies Bilder sind, Konstruktionen, Montagen aus ganz unterschiedlichen Bewusstseinsebenen. Der Videofilm auf dem Bildschirm ist ein eigener, virtueller Raum für imaginäre Welten. Der Monitor funktioniert wie ein Guckkasten mit der Oberfläche Bildschirm als Grenze zwischen innerer imaginierter und äußerer, vom Betrachter als seine jetzige, unmittelbare Erfahrung begriffener Realität. Auf der Mattscheibe begegnen und berühren sich die Bilder von Traum, Erinnerung und realitätsorientiertem Bewusstsein. Das Wiedererkennen und die verfremdende Montage markieren die Brüche in dem Verhältnis von Erinnerung und einem kritischen Bewusstsein. Die Lust an einer solchen Reflexion zeigt der Künstler in dem Spiel mit phantasievoller (Computer-)Animation der Bilderwelten, aber auch in der rollenhaften Verkleidung seiner selbst. So entstehen parabelhafte Geschichten, in denen er sich mit seinen Bildern verknüpft. Die Brüche schaffen Distanz, die der Künstler mit Humor und Ironie in Szene setzt, die ein Lachen über die Banalität der Bilder genauso erzeugt wie den Schrecken über die eingängigen und prägenden Klischees und Bildmuster, die er aufspürt und vorführt. Er stellt sie in ihrer Form als Möglichkeit in Frage, wie sie erinnert und wahrgenommen werden könnten, indem man auch die Mög-

No Sunshine 1997

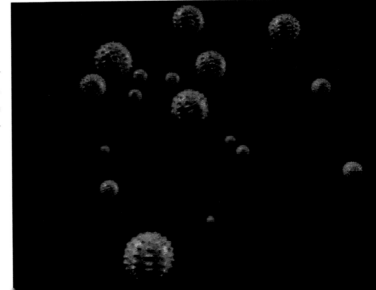

lichkeiten des Mediums in Betracht zieht, durch das sie gesehen werden. In diesem Sinne zwingt die jeweilige Installation der Monitore oder der Projektionen immer eine bestimmte Form der Wahrnehmung der Bilder und ihrer Vermittlung im Videofilm.

Wie in fast allen seinen Videoarbeiten personifiziert Bjørn Melhus in »No Sunshine« (1997) selbst die Protagonisten seiner kurzen filmischen Tragikomödie der Bewusstwerdung von Kindheitsmustern und der Frage nach Identität. Nachdem aus einem weiten dunklen Raum ein Schwarm synthetischer Himmelskörper oder roten Blutkörperchen ähnlicher, zellenförmiger Gebilde auf den Betrachter zuschwebt, erscheint Bjørn Melhus in einer solchen Zelle als »Zwillinge«, die zunächst wie eine Spiegelung erscheinen, wo doch kein Spiegel ist, nahezu identisch, um dann im Laufe der Handlung, auf den ersten Blick zunächst kaum wahrnehmbar, sich immer mehr zu unterscheiden. Es ereignet sich der Bruch der Identität sowohl in der Form des Films als auch in den beiden Rollen der Figur selbst.

Die Kindheitsprojektion hat ihre Form in den identischen Kostümen. Sie assoziieren die Erinnerung an die geschlechtslosen Spielzeugfiguren von Playmobil, die unzählige Kinderzimmer bevölkert haben und dies noch tun und als Bildmuster Pate stehen für die Wahrnehmung von Welt und das frühe, spielerische Zurechtfinden darin. Die Kindheits- projektion findet gleichzeitig statt in dem Song des Musikvideos, wodurch die Arbeit eine vertraute mediale Form vorgibt. Dieser »Song«, Grundlage der Geschichte, ist eine Neu- konstruktion aus Fragmenten der Stimmen zweier Kinderstars der Popmusik, Michael Jackson und Stevie Wonder, aus dem 60er-Jahre-Lied *Ain't no sunhine*. Der Wechselgesang der »Zwillinge« beginnt mit emotional gestimmten Lauten: »Hhhh, hhhh – Hhhh, hhhh; Hhhh, hhhh – Haaaaau...«. Er geht über in wechselseitiges Fragen: »You gonna look for me? For me? For me? – You gonna look for me? For you? For you? ...WewannaWewanna- Wewanna... Baby I, Baby I... I wanna this day...?« Das Stammeln der Bruchstücke und die leichte, infantil freundliche Zuwendung bleiben bedeutungsoffene Gesten und werden brüchig wie die sich einspielende Auflösung der räumlichen und handlungsorientierten Einheit des Bildes. Die Handlung erweitert sich auf drei Projektionsräume mit unter- schiedlichen Bildrealitäten, zwischen denen sich die Handlung und deren Wahrnehmung bewegen. Im Sinne verschiedener Bewusstseinsebenen agieren zunächst die Playmobil- Zwillinge in der Ebene der Bilderinnerung; in einem sich dann dahinter öffnenden zweiten Raum verkörpert Bjørn Melhus nun androgyne, gerade erwachsen werdende Figuren in hautförmiger Kleidung als zweite Spiegelung in das Unterbewusstsein (»we wanna, we wanna...«); wieder eröffnet sich der virtuelle makrokosmische oder mikrokosmische, wenn

wir an die Blutkörperchen denken, tiefschwarze Raum mit darin umherschwebenden, zell-förmig monadischen roten Gebilden als universelle Metapher, wo wir die Vorstellung ver-orten könnten.

Ausgelöst von einer Öffnung zu dem hinteren Raum und dem parallelen Geschehen um-kreisender Bewegung des zweiten Figurenpaars erfolgt eine Bewegung von einer nar-zisstisch ineinanderspielenden Zweiteilung zur Berührung, und zugleich ereignet sich der Bruch der Identität der Zwillinge auf beiden Ebenen. Die eine Figur sucht die Berührung, die andere weicht zurück. Die linke Hälfte des Paares verharrt in dem Zustand eines kör-perlichen Neutrums und fordert mit den Worten »Love me! … Love me!« die Liebe zu sich, während, tiefrot nun in der Farbe, die rechte Figur ihre Körperlichkeit entdeckt. Ihre Hände werden dafür zum Symbol. Sie löst sich vom zurückgebliebenen Teil, hat keinen Kontakt mehr zu ihm, der verfangen bleibt in autistischen, sich selbst abtastenden Bewegungen. Sie genießt nun die neu gewonnene Wahrnehmung ihrer körperlichen und emotionalen Existenz – »yeaaah, yeaaah…«.

Die Bildebenen vermischen sich, spiegeln und kommentieren sich gegenseitig. Der einzig durchgesprochene Satz – »Did you ever want something … and then one day you get it, and it's so wonderful to you« – aus der Michael-Jackson-Version des Songs ist ein Schlüssel der Bildhandlung. Aber auch er bleibt ein Fragment, ein offenes Bild. – »I wanna this day … «

In der Erinnerung der Bilder wie im Unterbewusstsein bleibt für die linke Hälfte als ein-zige Selbstbehauptung und Möglichkeit der Identität das Verharren im Bild bewusster Infantilität im Kostüm des Spielzeugs und die Erklärung des Kriegs: »Put'n down! Put'n down!… – We are at war!« Im Wechsel der Handlungsräume breitet sich Entsetzen aus über das Geschehen, den Bruch der Identität, die Auflösung des idyllisch romantischen Bilds von Kindheit. »Look over your shoulders, honey!« – die Aufforderung wird von den Figuren in beiden Existenzen wie ein Echo übernommen und an die rote Figur adressiert. Doch der Blick zurück in die Vergangenheit, auf das Spielmodell, bedeutet die Auflösung, die Implosion im Vakuum, wie dies metaphorisch abstrakt das Geschehen im dritten, kos-mischen Raum kommentiert. Die Kugel implodiert und verglüht wie eine Sonne. »Ain't no sunshine, ain't no sunshine – no – ain't no sunshine – no …« singen die beiden Playmobil-Figuren, bevor das Videobild in gleißendem Licht endgültig verglüht. Die Geschichte der Handlung funktioniert wie eine entlarvende Projektion über den Song des Musikvideos, wie ihn Bjørn Melhus neu komponiert, und wie die Feststellung der Absurdität dessen,

27

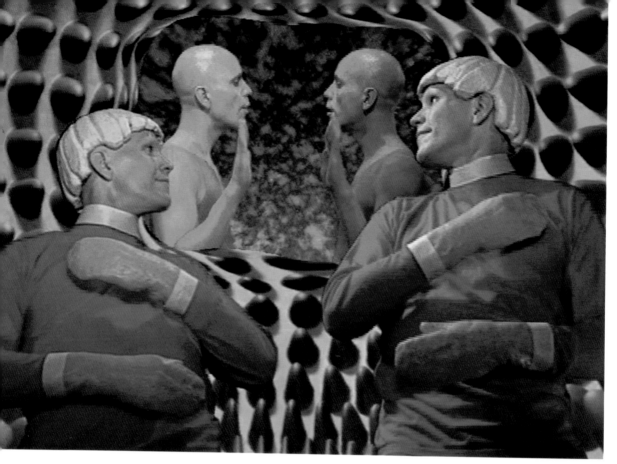

was von seinen Inhalten noch fragmentarisch erkennbar ist. Und dann wiederholt sich die ewige Wiederkehr des Gleichen, die Never-ending-Story. Die Bilder werden zum Ornament, zum Muster, zum Modell der Wahrnehmung von Kindheit.

Die beiden Monitore der Installation sind in einer zellenhaft engen Box so installiert, dass man das filmische Geschehen immer nur auf einem sehen und die Parallelität und räumliche Vervielfältigung im anderen nur ahnen kann. Auch da setzt sich die Konzeption der Spiegelung in die aktuelle Wahrnehmung des Betrachters fort – hier und dort, ich und das Gleiche neben mir.

Der Künstler spürt Topoi der Bilder von Kindheit, seiner Erinnerungsbilder von Kindheit auf, so pseudoromantisch wie klischeehaft ad absurdum geführt, dass die vermeintlich großen emotionalen Gesten der Unterhaltungsindustrie in ihrer Absurdität offenbar werden. Man wird verführerisch eingefangen in die Erinnerung populärer Erklärungsmuster. Zugleich leisten die Bilder auch ihren ideologiekritischen Offenbarungseid des Vakuums des Formenvokabulars von Kindheitsmustern, deren sich der Künstler bedient. Die in ihren

Formen generationsspezifische Innenschau, die man in dem Guckkasten Monitor miterlebt, ist ein synthetisches Bild eines in Szene gesetzten Psychogramms der Krise der Identitätsfindung. Der Ernst wird gebrochen durch die rückschauende, in Bruchstücken zitierende und assoziierende Mischung aus Bildern der Spielzeugwelt, der Popkultur in den Videoclips der Musikindustrie und Bilderwelt, die die Kunst, die Comic-Industrie und Werbung hervorbrachten. Das führt bis zu Andeutungen populärer Erklärungsmuster, die aus der die 6oer und 7oer Jahre ebenso prägenden Rezeption der Psychoanalyse abgeleitet werden und die selbst wieder Gegenstand einer kulturkritischen Analyse sein müssen, ihre mediale Vermittlung eingeschlossen. Unmissverständlich macht Bjørn Melhus deutlich, dass er sich in Bilder projiziert, sein gedoppeltes Alter Ego ein Teil davon ist. Er zeigt, wie diese Sinn und Bedeutung machen und zugleich sich in Mystifizierung, Ideologie und Absurdität verkehren. Der Erfahrungs- und Erkenntnisgewinn liegt in der Frage – »ain't no sunshine« –, in der das lustvoll erinnernde Spiel mit den Bildern sowie die Trauer und die Krise ihres Realitätsverlustes – was auch immer »Realität« bedeuten mag – so nahe beieinander liegen.

Das bildhafte Formenrepertoire, in das Bjørn Melhus seine Geschichte verkleidet, ist weit gefächert. Es beschränkt sich nicht auf das ideologiekritische Entlarven von Kindheitsbildmustern, sondern klinkt sich ein in die gegenwärtige Debatte um die Verwandlung in künstlerische Bildstrategien. Das Ganze vermittelt sich als Musik-Video-Clip. Anspielungen auf die Popkunst, die Vervielfältigung eines Andy Warhol, in Arbeiten wie »Again and Again« (1998) noch deutlicher zu erkennen, sind hier schon angedeutet. Parallel dazu die comichafte Überformung der Maskerade in Playmobilfiguren, von der schon die Rede war. An Bruce Naumans Videoarbeiten ist zu denken, an die Dramen ihrer spezifisch körperlichen Art der Imagination, die zum Beispiel in den kahlköpfigen Figuren der zweiten Ebene des Unterbewusstseins in Bjørn Melhus' »No Sunshine« eine Entsprechung haben: in der kreisenden Bewegung zu der Litanei »willacallheronthethatthetimearecomefrom bringsmacoffeeinma willacallhereonthethatthetime...« Oder man erinnert sich an die frühen *Art Make Up*-Filme Bruce Naumans (1967/68), in denen er z.B. seinen Körper mit Schminke in den Farben Weiß, Rot, Grün und Schwarz bemalt. Eine vergleichbare, emotional geladene Farbmetamorphose ist auch in den besagten Figuren Bjørn Melhus' zu beobachten. Schließlich lässt die Verkleidung, die Maskerade des Künstlers als Playmobilfigu-

No Sunshine 1997

ren, an eine Reihe vergleichbarer Bilder denken und an die damit verbundene Strategie der Verstellung, der Kostümierung, um mehr als eine Geschichte, mehr als eine Vision des Menschen zu offenbaren. In dieser Bildtradition steht Duchamp als *Rrose Sélavy* in Man Rays berühmter Photographie (1921), Duchamps wortspielerisches weibliches Alter Ego (éros c'est la vie). Auch Bjørn Melhus' Verkleidung und Handlung beinhaltet zu der schon benannten Bedeutung der Spur kindlich spielerischer Welt- und Selbstwahrnehmung das auffordernde Wortspiel des Namens ihrer stereotypen Vorbilder: play mobil. In diesem Zusammenhang mögen auch die als Clowns kostümierten Gestalten in vier Videos von Bruce Nauman im Bildgedächtnis aufscheinen, alle in frustrierend aussichtslosen Situationen zu beobachten. Sie erfüllen für den Künstler kollektive soziale Phantasien des Bruchs, des Scheiterns an der Realität, die nur im Bereich der Kunst und der Phantasie, in der distanzierten Betrachtung toleriert werden, wo das Tragisch-Komische mit Lachen quittiert wird. Auch Bjørn Melhus' Rollen haben diesen grotesken Charakter.

Für Cindy Shermans Werk ist die permanente Travestie als künstlerische Strategie wesentlich. Sie zeigt, und dabei bezieht sie sich nicht selten auch auf bestimmte Bilder (Stills) des Films, dass derselbe Mensch die verschiedensten Identitäten annehmen und verkörpern kann in Bildern, die ein mögliches Inneres nach außen kehren. Es ist der Möglichkeitssinn in der Frage nach Identität, gespeist aus so vielen nachhaltig einprägsamen Bildern, der Bedeutung evoziert, ohne aus dem Blickfeld zu verlieren, dass das Vorgeführte immer ein Rollenspiel ist, ein durchschaubares und doch geheimnisvoll bleibendes Täuschungsmanöver in den Bildern, denen Cindy Sherman oder Bjørn Melhus auf der Spur sind, genauso wie in den Bildern, in denen der Künstler sich jene neu als interpretierbare Identifikationsmuster zu eigen macht. Bjørn Melhus spielt in Kostümen, macht das Fragmentarische zu seinem spielerisch mobilen Moment, das Prozesshafte der Handlung wie der Möglichkeiten des Mediums zur Überformung und Überlagerung von Bedeutungen in den Rollen und Bildern, die er damit entwirft.

Bjørn Melhus stellt auf dem Wege der Spurensuche in den Bildern seiner Kindheit und deren Neuformierung auch ganz grundsätzlich die Frage nach den prägenden Ich-Findungen. Was ist das Ich? – eine uralte, ebenso banale wie schwerwiegende Frage, vielleicht *die* Frage des neuzeitlichen Denkens schlechthin und also auch der Bilder, auch der künstlerischen, die dies Denken gebiert. Nur einige, mit Blick auf die zur Rede stehende Kunst exemplarische Beispiele seien angeführt. Das selbstgewiss klingende, aufklärerische *Cogito, ergo sum* (Ich denke, also bin ich) Descartes' löst sich in der Dichtung und Philosophie des 19. und 20. Jahrhunderts in viele Facetten auf. Novalis schreibt: »Der Mensch ist

so gut Nichtich als Ich«, oder: »Ich ist nur durch ein Nichtich denkbar«. Und an anderer Stelle postuliert er: »Das Ich soll construiert werden.« Hegel bezeichnet das Ich als das »unglückliche, das entzweite Bewußtsein«. Kierkegaard spricht von dem »Selbst des Menschen, ...indem er sich zu sich selbst verhält, sich zu einem Andern verhält« (Die Krankheit zum Tod und Anderes). Sartre sucht auf dem Wege der reflexiven Selbstverdoppelung den Mangel an Selbstgewissheit zu überwinden: »C'est bien moi, ce redoublement continuel et réflexif.« Ernst Bloch betont das antizipatorische Moment in der Vervielfältigung der Bilder vom Selbst: »Ich bin. Aber ich habe mich nicht. Darum werden wir erst.« (Spuren, 1930) Poetisch und bestechend programmatisch ist die Formulierung Arthur Rimbauds: »Je est un autre« – Ich ist ein anderer (1871). Sie verweist auf das Geheimnis der Verwandlung, der Rolle, deren Gestalt zu dem Fremden führt, zu der Möglichkeit, sich im Fremden selbst abzubilden, neu zu (er)finden – Mimesis als das Sichzueigenmachen des Fremden (Adorno), des Fremdgewordenen und des Verborgenen. Das individuelle, subjektive wie das soziale Ich ist ein Konstrukt, begründet in der Fähigkeit des Menschen, sich selbst zu denken, vorzustellen und zu entwerfen – in Bildern. Solche Bilder werden ihm in die Wiege gelegt, sein Kinderzimmer ist voll davon, sie begleiten seine Bewusstwerdung wie zum Beispiel die Filme im Fernsehen, bilden sich im Unterbewusstsein ab in Bruchstücken und Mustern. Der Künstler kann sie wieder aufnehmen, auch die Ahnungen und das Wissen um sie, und er stellt dafür in der Form seiner Bilder exemplarische Wahrnehmungsmodelle zur Ansicht vor, modelliert die Formen genauso wie die damit verbundenen Emotionen und deren Wahrnehmung.

Bjørn Melhus schafft mittels der elektronischen Medien, mit Video – lateinisch: ich sehe – und dem Computer, dem programmgesteuerten In-Rechnung-Stellen der Komponenten unserer Wahrnehmung, neue Existenzen aus Fragmenten der Popmusik, ihrer Texte und Bilder, die seine Generation geprägt haben. Die Entwicklung zum Selbstbewusstsein wird in einer Metapher der Entdeckung des Ichs als Körper, als Hand, als Emotionsfähigkeit vorgeführt, modellhaft eingekleidet in die Kostümierung aus Elementen der Zwischenwelt der Kinderspielzeuge, der Popkultur und der computersimulierten, virtuellen Erfindungen auf dem Bildschirm. In der Fragmentierung entpuppt sich deren Bedeutung ebenso existentiell wie banal und absurd, wenn man unter anderem der Musik und den Textfragmenten Aufmerksamkeit zuwendet, mit denen der Künstler seine Körpersprache synchronisiert. Meisterhaft spielt Bjørn Melhus die naive infantile Gestimmtheit und bringt den Konflikt in Mimik und Körpersprache treffend zum Ausdruck. Er spiegelt die Bilder seiner Television-Erinnerung, und in ihrer entfremdeten Andersheit verweist er sie auf das Medium, auf die Mattscheibe, in den Guckkasten Monitor zurück.

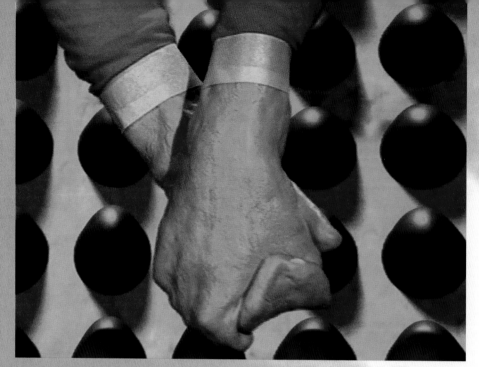

In allen seinen Arbeiten verkörpert er seine in Bildern gefundenen Existenzen selbst und spitzt damit die Fragen nach dem Ich, nach Identität und Selbstverständnis zu, als existentielle wie als mediale Schöpfung. Reale und virtuelle Existenz berühren sich, die Grenzen werden fließend und durchlässig. Und darum geht es in der Kunst wie in keiner anderen, Bilder hervorbringenden Form der Vorstellungskraft, der Imagination.

Werner Meyer

Vgl. Bruce Nauman, Anthro/Socio, 1991, in: documenta IX, Ausstellungskatalog Kassel, Stuttgart 1992, S. 396 f.

Vgl. Bruce Nauman, Flesh to White to Black to Flesh, 1968.

Bruce Nauman, Clown Torture, 1987.

Vgl. Robert Musil, Der Mann ohne Eigenschaften, Reinbek bei Hamburg 1978, S. 16 f.

Vgl. dazu ausführlicher Armin Zweites Texte »Vorwort« und »Ich ist etwas Anderes« in: Ich ist etwas Anderes. Kunst am Ende des 20. Jahrhunderts. Global Art Rheinland 2000; hrsg. von Armin Zweite, Doris Krystof und Reinhard Spieler, Köln 2000, S. 27-50.

NO SUNSHINE

Did you ever want something,
that you know you shouldn't have,
the more you know you shouldn't have it,
the more you want it.
And then one day you get it,
and it's so good to you.

No Sunshine 1997

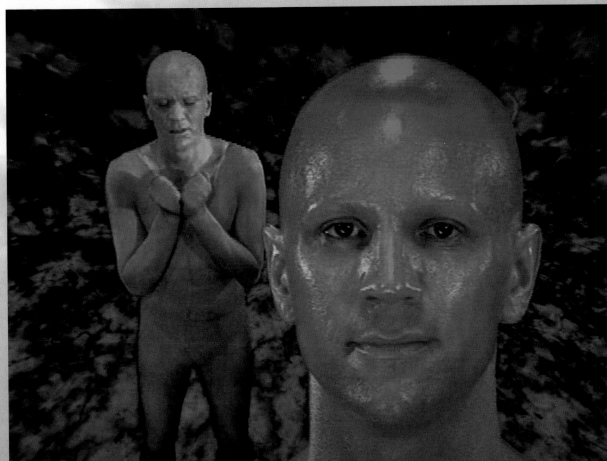

No Sunshine (Auszug aus Storyboard /Excerpt from the storyboard 1997)

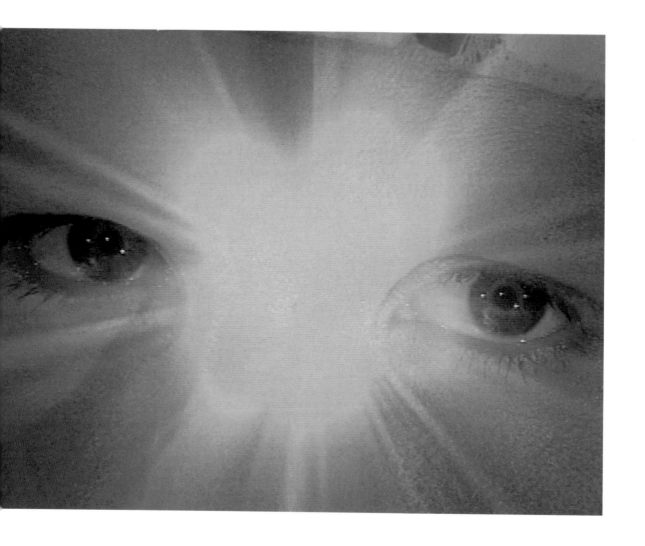

No Sunshine 1997

NO SUNSHINE

Bjørn Melhus belongs to the first generation to grow up with the medium of television and for which this medium, like no other, provided the models and patterns of identification for reality and dream worlds. The initial interest in much of his work as an artist is in tracing this world of images. The tape recorder for pop music and later video recordings for films mean a direct reflection in the sense of seeing again, of a selected, easily accessed archive by means of which these memories and memorized images are put at one's disposal. Bjørn Melhus' artistic processing of these worlds of images takes as its theme these patterns of identification as fragments of memory that form anew in the adult's current stories, that insert themselves into the question of one's own I, into the image of himself that the artist creates, knowing full well that these, too, are images, constructions, assemblies from quite diverse levels of consciousness. The video film on the monitor is its own virtual space for imaginary worlds. The monitor functions like a peep-box with the monitor surface as the boundary between an imagined inner reality and an outer reality that the viewer grasps as his own current, direct experience. Images from dreams, memory, and reality-oriented consciousness meet and touch on the monitor. Recognition and alienated assembly mark the breaks in the relationship between memory and a critical awareness. The artist shows pleasure in such reflection in playing with the imaginative (computer) animation of the image worlds, but also in his dressing up to play roles. Parable-like stories thus emerge in which he ties himself to his images. The breaks create distance, which the artist stages with humor and irony, triggering laughter at the banality of the images and startling one with the catchy and molding clichés and image patterns he finds and presents. He questions them in their form as possibility, as they could be remembered and perceived, by considering also the possibilities of the medium through which they are seen. In this sense, the respective installation of the monitors or projections always force a certain form of perception of the images and their mediation in video film.

In »No Sunshine« (1997), as in almost all his video works, Bjørn Melhus himself personifies the protagonist of his short cinematic tragicomedy of becoming aware of childhood

patterns and the question of identity. After a swarm of synthetic heavenly bodies or shapes resembling red blood cells floats toward the viewer from a large, dark room, Bjørn Melhus appears in one such cell as »twins«. Initially they seem like mirror reflections, almost identical though there is no mirror; in the course of the action, at first almost imperceptibly, they increasingly differ. The break in identity occurs in the form of the film as well as in the figure's two roles.

The childhood projection has its form in the identical costumes. They trigger associations of the remembered sexless toy figures of Playmobil, which populated and still populate countless children's rooms and which, as image patterns, set the stage for the perception of the world and the child's early, playful coming to terms with it. At the same time, the childhood projection plays out in the song of the music video, through which the work presents a familiar media form. This »song«, the foundation of the story, is a new construction from fragments of the voices of two child stars of pop music, Michael Jackson and Stevie Wonder, from the 1960's song *Ain't no Sunshine*. The antiphonal singing of these »twins« begins with emotionally voiced sounds: »Hhhh, hhhh – Hhhh, hhhh; Hhhh, hhhh – Haaaaau... « It shifts into alternating questions: »You gonna look for me? For me? For Me? – You gonna look for me? For you? For you?... WewannaWewannaWewanna... Baby I, Baby I... I wanna this day...?« The stammered fragments and the light, infantile friendliness remain gestures whose meaning is open; they fray like the beginning dissolution of the spatial and plot-oriented unity of the image. The plot expands to three projection rooms with various image realities, between which move the plot and its perception. Initially, the Playmobil twins act on the level of image memory, in the sense of different levels of consciousness; in a second room that then opens up behind the first, Bjørn Melhus now embodies androgynous figures in the process of growing up, in skin-like clothing, as a second mirroring in the subconscious (»we wanna, we wanna... «); once again, the virtual macrocosmic or (if we think of the blood cells) microcosmic deep black space, with its floating, cell-shaped, monadic red structures, opens up as a universal metaphor for where we can locate the performance.

Initiated by an opening to the back room and to the parallel occurrence of the circling movement of the second pair of figures, a narcissistic division into two becomes a touching, and at the same time, the twins' identity is broken on both levels. One figure seeks contact, the other withdraws. The left half of the pair remains corporeally neuter and demands love for itself with the words »Love me! ... Love me!« while the right-hand figure, now a deep red color, discovers its corporeality, symbolized by its hands. The hands

dissociate from the rest of the body, losing contact with it, which remains captive in autistic, self-exploring motions. The figure enjoys the newly won perception of its bodily and emotional existence – »yeaaah, yeaaah...«.

The image levels mix with, mirror, and comment on each other. The only completely spoken sentence – »Did you ever want something...and then one day you get it, and it's so wonderful to you« – from the Michael Jackson version of the song is a key to the action in the images. But it too remains a fragment, an open image. – »I wanna this day...«

In the memory of the images, as in the subconscious, the left half's only remaining possibility of self-assertion and identity is to stick it out in the image of conscious infantility in the costume of the toy and the declaration of war: »Put'n down! Put'n down!... – We are at war!« In the shift between the rooms of the action, shock spreads at what happens, the breakdown of identity, the dissolution of the idyllically romantic image of childhood. »Look over your shoulders, honey!« – the figures in both existences take up this imperative like an echo and address it to the red figure. But the glance back into the past, at the toy model, means dissolution, implosion in a vacuum, as is metaphorically and abstractly commented in the third, cosmic room. The sphere implodes and its glow slowly dies, like a sun. »Ain't no sunshine, ain't no sunshine – no – ain't no sunshine – no...,« sing the two Playmobil figures, before the video image finally extinguishes in glaring light. The story of the action functions like an unmasking projection on the music video's song, as re-composed by Bjørn Melhus, and like a registration of the absurdity of what is still fragmentarily recognizable from its content. And then the eternal recurrence repeats itself, the never-ending story. The images become ornament, pattern, a model of perception of childhood.

The installation's two monitors are mounted in a cell-like, narrow box in such a way that the cinematic happenings can always be seen only on one of them and that the viewer can only guess at the parallel and spatial multiplication in the other one. Here, too, the concept of mirroring is carried forward in the viewer's current perception – here and there, I and what is the same, next to me. The artist traces themes of the images of childhood, his remembered images of childhood, taken to such pseudo-romantic and cliché-ridden extremes that the supposedly grand emotional gestures of the entertainment industry are revealed in their absurdity. At the same time, the images also declare their ideology-critical bankruptcy of the vacuum of the vocabulary of forms of the patterns of childhood used by the artist. The generation-specific internal view in their forms, which we share as

if in a peep-box, is a synthetic image of a staged psychogram of the crisis of finding identity. The seriousness is undercut by the retrospective, fragmentarily quoted, associative mixture of images from the world of toys, from pop culture in the music industry's video clips, and from the world of images that art, the comic-book industry, and advertising created. This goes as far as hints of popular patterns of explanation, which derive from the equally molding 1960's and 1970's reception of psychoanalysis and which ought to be the object of a culture-critical analysis themselves, together with their media presentation. Bjørn Melhus makes it unmistakably clear that he projects himself in pictures and that his doubled alter ego is a part of this. He shows how these make sense and meaning and at the same time turn into mystification, ideology, and absurdity. The gain in experience and knowledge lies in the question (»ain't no sunshine«), in which the pleasurable, remembering play with the images lies so close to the sadness and crisis of their loss of reality – whatever »reality« may mean.

The repertoire of visual forms in which Bjørn Melhus clothes his story is a wide spectrum. He does not limit himself to ideology-critical exposure of the patterns of images of childhood, but joins in the current debate on the transformation in artistic picture strategies. The whole thing presents itself as a music video clip. Here we already find hints of references to pop art, the multiples of an Andy Warhol, which are even more clearly recognizable in works like »Again and Again« (1998). This is paralleled by the comic-book-like transformation of the masquerade in the aforementioned Play mobil figures. We recall Bruce Nauman's video works, the drama of their specifically corporeal style of imagination, which has a correspondence in, for example, the bald figures of the second level of the subconscious in Bjørn Melhus' »No Sunshine«: in the circular motion to the litany »willacallheronthethatthetimearecomefrom bringsmacoffeeinma willacallheronthethatthetime...« Or we recall Bruce Nauman's early *Art Make Up* films (1967 / 68), in which, for example, he painted his body with white, red, green, and black make-up. A comparable, emotionally-charged color metamorphosis can also be observed in Bjørn Melhus' figures. Finally, the disguise, the artist's masquerade as Playmobil figures recalls a number of comparable images and the associated strategy of dissemblance, of costuming, in order to

40

reveal more than one story, more than one vision of humankind. In Man Ray's famous photograph (1921), Duchamp stands in this image tradition as *Rrose Sélavy*, his female alter ego, rich in word play (éros c'est la vie). Along with the aforementioned meaning of the tracing of childlike, playful perception of the world and the self, Bjørn Melhus' disguise and action also contain the challenging word play of the name of its stereotypical models: play mobile. In this context, the figures costumed as clowns in four of Bruce Nauman's videos, all observable in frustratingly hopeless situations, may shimmer through in our image memory.

For the artist, they fulfill collective social fantasies of breakage, of failure induced by reality, which can be tolerated only in the realm of art and imagination, viewed from a distance where laughter is the answer to the tragicomical. Bjørn Melhus' roles, too, have this grotesque character.

No Sunshine 1997

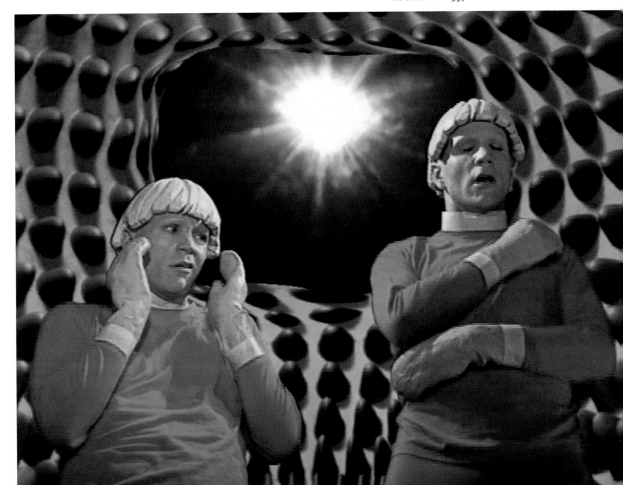

Constant travesty is essential as the artistic strategy in Cindy Sherman's work. She shows, often referring to specific still images from film, that the same person can take on and embody the most various identities in images that bring a possible interior to the exterior. It is the sense of possibility in the question of identity, fed by so many lastingly molding images, that evokes meaning without ever forgetting that what is presented is always role-playing, a transparent and yet persistently enigmatic deceptive maneuver in the images that Cindy Sherman and Bjørn Melhus both seek to track down, just as in the images in which the artist makes each newly interpretable pattern of identification his own. Bjørn Melhus plays in costumes: he makes the fragmentary his playfully mobile moment; and the processual aspect of action as well as of the possibilities of the medium are turned into the reshaping and overlaying of meanings in the roles and images that he thereby designs.

On the path of tracing the images of his childhood and their reshaping, Bjørn Melhus also poses the fundamental question of the formative finding of the I. What is the I? – an ancient question, as banal as it is deep, perhaps the question of thought in the modern age and thus also of the images, including the artistic images, that this thought gives birth to. Let us mention only a few examples that throw particular light on the art in question. Descartes' self-confident sounding, Enlightenment-era *Cogito, ergo sum* (»I think, therefore I am«) dissolves into many facets in the poetry and philosophy of the 19th and 20th centuries. Novalis writes: »Man is just as much Not-I as I« and »I is conceivable only through a Not-I.« And elsewhere he postulates: »The I is to be constructed.« Hegel terms the I the »unhappy, the divided consciousness«. Kierkegaard speaks of the »self of man, ... by relating to himself, he relates to others« (Die Krankheit zum Tod und Anderes). Sartre took the path of reflective self-doubling to seek to overcome the lack of self-certainty: »C'est bien moi, ce redoublement continuel et reflexif.« Ernst Bloch emphasizes the anticipatory moment in the multiplication of images of the self: »I am. But I don't have myself. That's why we are still becoming.« (Spuren, 1930) Arthur Rimbaud's formulation is poetic and convincingly programmatic: »Je est un autre« – I is another (1871). It points to the secret of transformation, of the role, whose form leads to the alien, to the possibility of creating and of (re-)inventing one's image in the alien – mimicry as the appropriation of the alien (Adorno), of what has become alien, and of the hidden. The individual, subjective, and social I is a construct, based in the human ability to conceive, imagine, and design oneself – in images. Such images are placed in our cradle, our children's room is full of them, they (for example the films on television) accompany our growing conscious, and, in fragments and patterns, they form their images in our subconscious. The artist can take them

up again, as well as his inklings and knowledge of them, and he presents to our view models of perception in the form of his images; he models the forms as well as the accompanying emotions and their perception.

Using the electronic media, with video (Latin: I see) and the computer (the program-directed invoice of the components of our perception), Bjørn Melhus creates new existences from fragments of pop music and their texts and images, which shaped his generation. The development toward consciousness of oneself is presented in a metaphor of the discovery of the I as body, as hand, as capability of feeling emotions. Like a model, it is clothed in the costume of elements of the interstitial world of children's toys, pop culture, and computer-simulated, virtual inventions on the monitor. Their meaning is revealed in the fragmentation, in equal parts existentially, banally, and absurdly, when we direct our attention to the music and the text fragments with which the artist synchronizes his body language. Bjørn Melhus masterfully plays the naive, infantile mood and tellingly expresses the conflict in facial expression and body language. He mirrors the images of his television memories, and in their alienated otherness he points them back toward the medium, to the peep-box monitor.

In all his works, he personally embodies the existences found in his images, thus bringing the question of the I, of identity and self-concept, to a head, as existential as all media creation. Real and virtual existence touch each other, the boundaries blur and become permeable. And that is the point in art more than in any other image-producing form of the imagination.

WERNER MEYER

Cf. Bruce Nauman, Anthro / Socio, 1991, in: documenta IX, Exhibition Catalogue Kassel, Stuttgart 1992, p. 396 f.

Cf. Bruce Nauman, Flesh to White to Black to Flesh, 1968.

Bruce Nauman, Clown Torture, 1987.

Cf. Robert Musil, Der Mann ohne Eigenschaften, Reinbek bei Hamburg 1978, p. 16 f.

Cf. in more detail Armin Zweite's texts »Vorwort« and »Ich ist etwas Anderes« in: Ich ist etwas Anderes. Kunst am Ende des 20. Jahrhunderts. Global Art Rheinland 2000; ed. Armin Zweite, Doris Krystof and Reinhard Spieler, Cologne 2000, p. 27 - 50.

BLUE MOON – OUT OF THE BLUE

Die Arbeit »Blue Moon« zeigt die für Bjørn Melhus typische Doppelung bzw. Zweiteilung der Bild- und Tonebene, auf der er vielfach erst bei einem zweiten Blick oder beim zweiten Hören erkennbare Bezüge entwickelt, in der sich Bild und Ton wechselseitig kommentieren. Das akustische Ausgangsmaterial, das die Grundfolie zu »Blue Moon bildet«, sind zwei Songs von Elvis Presley, die hier exemplarisch für die amerikanische Popkultur genommen werden können. Das dominierende visuelle Bild dagegen ist die Figur des Schlumpf, die vielleicht weltweit erfolgreichste europäische Comicfigur, die als eine Art medialer Re-Import im europäischen Fernsehen aber erst Erfolg hatte, nachdem sie in Amerika populär geworden war. Als Metapher für den immateriellen Bildertransport taucht immer wieder das Bild einer großen Richtantenne auf. Subtile Farb-/Formbezüge (z.B. der Farbkontrast weiß/blau und die entsprechenden Formen von Schlumpfmütze und Mondsichel) verdichten Bilder und Text zu einer emotionalen Einheit, die jedoch auch ironisch gebrochen wird – wenn z.B. Bild und Ton bei den Worten »you lied« (du logst) asynchron werden. Humorvoll und ironisch entwickelt Bjørn Melhus aus dem trivialen und gleichzeitig emotionsgeladenen Text eine Befragung nach den Mustern der Identifikation (z.B. die leicht nach unten transponierte »männliche« Stimme, die zum Mund im unrasierten männlichen Gesicht »passt«, und die Falsettstimme Elvis Presleys zum glatten, eher weiblichen Gesicht des Schlumpf).

Der den Bildprojektionen von »Blue Moon« gegenüberliegende Monitor gibt die Arbeit »Out of the Blue« wieder, die als Kommentar und Erläuterung zu verstehen ist. Das Bild kann wie ein ironischer Kommentar auf den Wahrheitsanspruch der Bilder gesehen werden. Der Text erzählt die wahre Geschichte vom »Kulturaustausch« zwischen Amerika und Europa (in Bezug auf den Schlumpf), während das »wahre« Gesicht des Erzählers verborgen ist.

Blue Moon / Out of the Blue 1997/1998 (Installation Stadtgalerie Saarbrücken 2001)

BLUE MOON – OUT OF THE BLUE

Typically for Bjørn Melhus, the work »Blue Moon« shows the doubling or division of the image and sound levels, on which he develops mutually-commenting connections that are often recognizable only on second glance or second listening. The acoustic raw material used as the basic foil for »Blue Moon« is two songs by Elvis Presley, which can be taken here as symbols of American pop culture. The dominant visual image, however, is that of the »Schlumpf«, the European comic book character perhaps most successful throughout the world. But it was successful in European television as a kind of media re-import, only after becoming popular in America. The picture of a large unidirectional antenna repeatedly appears as a metaphor for the immaterial transport of images. Subtle color and form relationships (for example, the color contrast white / blue and the corresponding forms of the Schlumpf's cap and the crescent moon) condense images and text into an emotional unity. This is nevertheless ironically broken, for example when the picture is not synchronized with the tone when the words »you lied« are spoken. With humor and irony, Bjørn Melhus develops the trivial and simultaneously emotionally-charged text into an examination of the patterns of identification (for example, the »male« voice slightly transposed toward the bass, which »fits« the mouth of the un-shaven male face; and Elvis Presley's falsetto, which fits the smooth, more feminine face of the Schlumpf).

The monitor across from the image projections of »Blue Moon« presents the work »Out of the Blue«, which is to be understood as commentary and explanation. The image can be seen as an ironic commentary on the images' claim to truth. The text tells the true story of the »cultural exchange« between America and Europe (in regard to the Schlumpf), while the »true« face of the narrator is hidden.

BERND SCHULZ

45

OUT OF THE BLUE

Hello. This is out of the blue ... this is for you.

Who am I? What kind of videomaker am I? I thought the work that I'm doing in different variations to explore my identity and ... the media itself would express my personal feelings at this time, and shows me as a specific cultural phenomenon. Maybe not. Maybe it needs an explanation. Some theory. A voice-over ... or more ... a voice inside. Inside a brown paper bag. So, who am I?

I was procreated in summer 1965 and born in spring 1966. My childhood in the late 60s and 70s in West Germany was influenced by American TV series and movies. I'm a part of the first European TV generation. I enjoyed all the cultural imports from the U.S., like Flipper, Fury, Lassie ... they were my friends ... oh, and a lot of Western series, of course ... The other world was behind the screen, a world that was called America. And ... it created magic and desire. In my children's games, I always tried to simulate this world. I had a secret place, about a half mile away from home, that I called the Wild West. It was my Wild West. I remember it as place ...

as seen on TV. It wasn't. It was a construction site of a scripted, West German suburb in the early seventies. Maybe the fact that this was still a construction site in a cleaned-up world was the only wild part – beside my fantasies, of course. But making video is sometimes also a construction site ... And there was a voice in the air, the voice of Elvis, which escaped from the room of my eight years older sister, when I felt lonesome tonight ... No other musician in the world got so many impersonators. You can find the rules for Elvis-impersonating on the Internet.

But that's the 90s, where we are right now. What does impersonating mean? Whom do I impersonate? A brown paper bag? Who am I? In my first video self-portrait in 1991, I edited fragments of narrations from TV to create a new monologue. A statement of media identification. In my next video self-portrait, the same year, the monologue turned into a dialogue. Since then, most of my work is based on a dialogue – a dialogue between me and myself. This is different because I'm talking to you ... and you can talk to me. But you can't come in to remove my paper

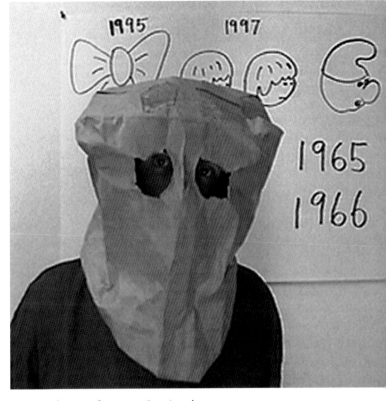

bag. So, who am I? Whom do I try to impersonate, if it's not a brown paper bag?

My work is identity research in the mass media imprints of a specific generation. The impersonated models of my recent work are copies of icons which were generated by mass media, the pop culture of mass production; sometimes they are toys themselves, referring to a never-ending childhood. Please, believe me, I'm completely innocent. My work is sometimes coded and for some people readable, for some not. There was the reciprocal Dorothy with her bow in 1995. The Playmobil twins from »No Sunshine«, in 1997. Here are two of the many originals. Look, they look the same. And that's the smurf from all the »Blue Moon« versions. And here is a smurf that I brought over from Europe last summer. It was the first smurf in my life. Later I had about 25 of them. Until the year Elvis Presley died. But the smurf was different, the smurf was European. The first smurf figure appeared in 1965 and was invented by Peyo, his real name was Pierre Culliford, a Belgian from Brussels. In 1966, the angry smurf came out. The figures were quite successful in Europe.

In 1982, the smurfs went to Los Angeles, where the Hanna-Barbera Studios produced over 150 episodes of smurf cartoons for American TV. So Mickey went to Europe, the smurf to America. This is called cultural exchange. Some people say the smurfs are communists, because the wear they same clothes and their leader looks like Karl Marx. I don't know ... The smurf in Blue Moon is displaced ... in the Wild West. He appears and disappears, as a signal. Standing there with emptiness all around. Sure, he is lying, there is no cause to doubt.

47

He … We don't even know if it's a he or
an it. There are no specific signs. Like my
former work, Blue Moon is also based on
a dialogue. There is the powerful deep
masculine voice, ruling the sentimental,
displaced smurf. The installation version
was an experiment in shifting images and
sound from one monitor to the next.
In »Blue Moon« Horses and Fire, I
restructured the digital pre-produced sound
track and extracted the black-and-white
image of the masculine voice, its voice-over,
but added some landscapes, horses, and fire
from the John Ford movie, *Rio Grande*. This
was supposed to be a special as-seen-on-TV
landscape, but I kicked it out again. The
horses are still left as a secret desire of the
smurf. But I didn't like the whole version
in the end. So I re-edited the whole piece
again. First the sound, then the image.
Without found footage … The black-and-
white masculine mouth went back in again.
Finally »Blue Moon« is the final version.
This is the end of the blue. It came out of
the blue of the blue of video color.
I will fade out in a few seconds. Goodbye.
And thank you for your time.

Bjørn Melhus

Out of the Blue 1997/1998

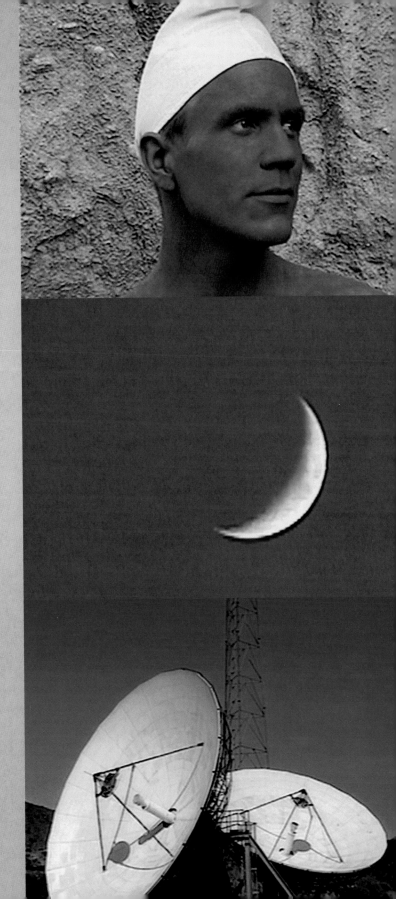

BLUE MOON

I wonder if …
And I have no cause to doubt.

And I'm standing there …
And I'm standing there …

And I have no cause to doubt.

You acted strange and why I'll never know.
You acted strange and why I'll never know.

And I have no cause to doubt.
And I have no cause to doubt.

And I'm standing there …

With emptiness all around.
Emptiness all around.

And I have no cause to doubt.

You acted strange and why I'll never know.

Honey you lied.
Honey you lied.
Honey you lied.

With emptiness all around.
Emptiness all around.

Blue Moon 1997 / 1998

AGAIN & AGAIN (THE BORDERER)

Ausgehend vom Originalton einer amerikanischen Werbesendung, in der eine Schmuck-verkäuferin auftritt, entwickelt Melhus in »Again & Again (The Borderer)«, 1998, eine bild-nerische Horrorvision vom Klonen des perfekten und geschlechtslosen Menschen. Im Herz-schlagrhythmus vervielfältigt sich die Figur, deren Selbstverliebtheit und Bewunderung seiner Doppelgänger wie ein sich selbst verstärkender Prozess erscheinen.

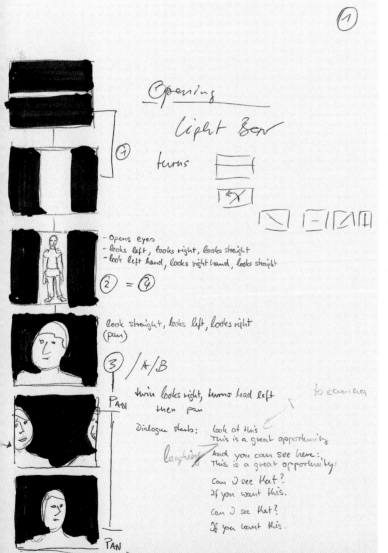

Die Arbeit wurde mit einem Produktions-stipendium des Long Beach Museum of Art realisiert.

Starting with the original sound on tape of an American advertising broadcast in which a jewelry saleswoman appears, Melhus de-velops in »Again & Again (The Borderer)«, 1998, a visual horror vision of the cloning of the perfect and sexless person. The fig-ure multiplies in the rhythm of a beating heart. Its self-infatuation and its admiration for its double seem like a self-reinforcing process.

The work was realized with a production grant from the Long Beach Museum of Art.

BERND SCHULZ

Again & Again (The Borderer)
(Auszug aus Storyboard/Excerpt from the storyboard 1998)

- looks left, looks right, looks straight

④

start at left!
figutive!

Variationen
testen!

5%

May be it's just me!

May be it's just me!

I tell you, this is true, this is real

to be honest with you...

I tell you, this is not cosmetic

to be honest with you

à hhhh (laughter)

And pow! It pops out you!

dreihon

Getting yourself

Can J see that

Getting yourself

' Can J see that

But you have to trust me.

(wien) Ohehey

But you have to trust me

kill kill kill kill

PAN

PAN

⑥ Body stehet me

Again & Again (The Borderer) (Auszug aus Storyboard / Excerpt from the storyboard 1998) 51

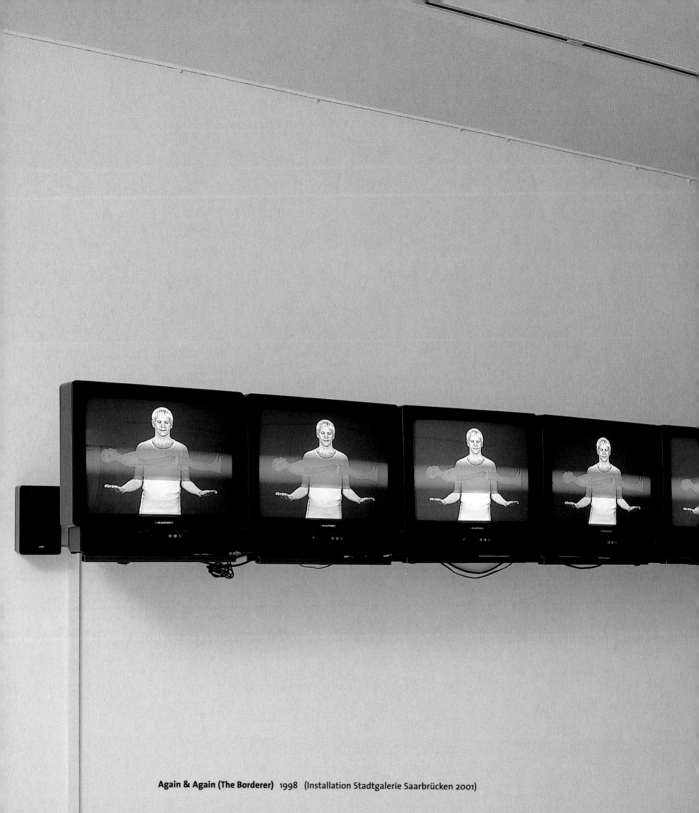

Again & Again (The Borderer) 1998 (Installation Stadtgalerie Saarbrücken 2001)

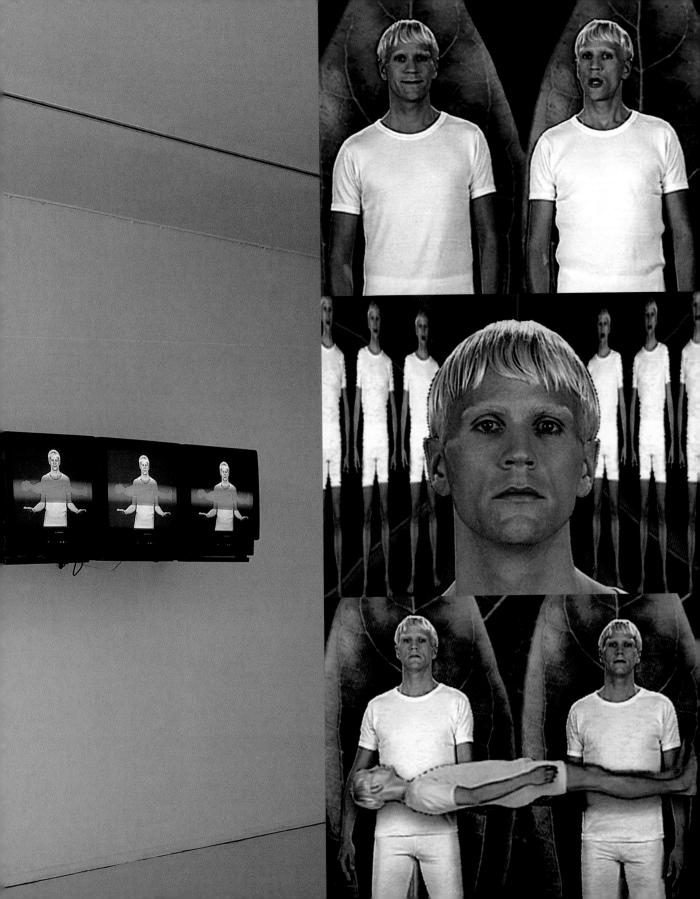

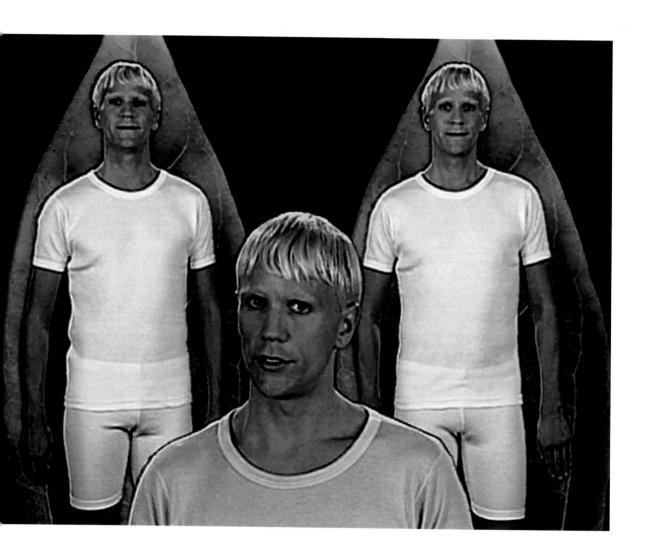

Again & Again (The Borderer) 1998

KÖRPERPHANTASIEN

Von Schafen und Menschen

1. »Neunzehnhundertdreiundsiebzig«, sagte er nachdenklich. »Ich finde, die Jahreszahlen klingen immer seltsamer. Neunzehnhundertdreiundsiebzig hört sich an wie so etwas aus diesen Comics, mit Todesstrahlen und Robotern und außerirdischen Ungeheuern. Und das Jahr, in dem ich geboren bin, klingt jetzt nach Postkutschen und Straßenräubern und Krinolinen und Fächern und Schnupftabaksdosen...« *Kingsley Amis, Ending Up*

2. Ein Schaf ist geklont worden; da waren es zwei Schafe (»›Dieselben?‹ – ›Was, dieselben?!‹«, wie es bei Valentin heißt). Die Nachricht – zu der sich sogleich weitere über Affen und über die begeisterten Wunschmeldungen aus den Reihen unserer eigenen Spezies gesellten – löst neben den ersten vorsorglichen Anwartschaftsgesuchen eine diffuse Beunruhigung aus. Viel mehr aber nicht. Haben wir das nicht schon lange gewusst? Das sind geahnte Möglichkeiten. Wie manche anderen Erkenntniskatastrophen ist auch diese in den vagabundierenden Phantasien des einschlägigen Erzählens schon so häufig vorweggenommen worden, dass ihr Eintreten in der Realität zwar noch vage irritiert, dabei aber gleichzeitig irgendwie auch schon ein alter Hut ist. Vielleicht bedeutet diese Ambivalenz nichts anderes als: Es ist unbegreiflich, was wir da erfahren. Durch den kleinen Riss dieses Zwiespalts einen Blick auf einige Fundstücke aus den Literaturphantasien der vergangenen Jahrhunderte zu werfen (und auch unser Jahrhundert ist ja so gut wie vergangen), mag ein wenig Material ergeben für das Nachdenken über diese Novität und all die anderen Meldungen und Gerüchte und lustlosen Diskussionen über Organhandel und Hirntod, über tiefgekühlte Semikadaver, die auf eine Therapie für das noch Unheilbare warten, über genetische Korrekturen und fötale Selektion. Wir müssen darüber nachdenken, so gut wir es vermögen, ohne noch hoffen zu dürfen, dass unsere moralische Phantasie je unsere technologischen Möglichkeiten einholen wird. Da können wir uns auf der Suche nach Fingerzeigen ebenso gut auch im Labyrinth der alten Guckkastenbilder aus den Märchen, Comics und Magazinen weitertasten. Diese neueste Erfindung tritt uns im Augenblick ihres Ursprungs so sehr wie ein Bild eines verschollenen phantastischen Films entgegen, dass es interessant sein könnte, dieses Bild mit tatsächlich älteren Verwandten zu vergleichen.

Die neue Technik verwischt auf eigenartige Weise den klaren Gegensatz zwischen »künstlich« und »natürlich«. Hinter dem unschuldigen Blick des schottischen Schafes ist sogleich die Zukunftsgestalt des ersten geklonten Menschen aufgetaucht. Wäre ein solcher Mensch, dem der Charakter des Naturwesens ja nicht abzusprechen wäre, ein »künstlicher Mensch«? Gehört er im Rahmen einer Topik des Phantastischen neben all die Automaten und Androiden, die wir der Kürze halber hier unter dem Begriff des Roboters zusammenfassen wollen (»extern« hergestellt vom Menschen, seien es auch Homunculi)? Es ist offensichtlich, dass eine andere Grundfigur des Phantastischen hier größere Affinität besitzt: der Doppelgänger.

Der Klon ist die Multiplikation der eigenen Identität in den Raum des »Anderen« hinein, eine Durchsetzung des Anderen mit »Ich«, eine Usurpation des Nichtich-Raumes. Alle haben das gleiche Gesicht, und vom Standpunkt des Geklonten aus ist es das eigene; er schaut um sich her immer in den Spiegel. Der Doppelgänger war in all seinen Formen von Spiegelbild und Schatten stets eine bedrohliche Erscheinung; die abergläubische Scheu vor der Verdoppelung geht in frühen Gesellschaften bis zur Zwillingstötung. Demgegenüber scheint das neue Double, das über unseren Horizont späht, der Klon, zunächst etwas fast Gemütliches zu haben, etwas Glattes, Harmloses – etwas Schafgesichtiges eben. Etwas Beruhigendes. Das Europaparlament hat eine erste Resolution gegen das Klonen von Menschen verfasst, im klassischen Ton flammender humanistischer Ohnmacht. Und doch wird es kaum gelingen, die Öffentlichkeit, die sich für die Möglichkeit interessiert, Boris Becker zu vervielfachen, wirklich davon zu überzeugen, dass diese Technik bedrohlich ist. Bedrohlich? Mäh. Es ist natürlich ein Zufall, dass die erste Verkörperung des neuen Prinzips in der Welt der Säugetiere ein Schaf war, aber Zufälle sind gewiss dazu da, dass man sie symbolisch nimmt, wenn sie es derart dreist treiben.

Früher war die Gestalt des Doppelgängers in der Tat eine Bedrohung, insofern sie die Individualität zu verwischen drohte. Nun verdoppelt sich die Individualität oder multipliziert sich ins Unendliche, und das scheint nicht Auflösung zu bedeuten, sondern im Gegenteil Machtzuwachs; die Vervielfachung bekräftigt wider alle Logik geradezu die Individualität (oder das, was man noch als eine solche zu besitzen meint). Sortiert man die Formen des »künstlichen Menschen«, welche unsere Phantasie hervorgebracht hat, wird im Vergleich rasch erkennbar, wie sehr die ganzen schillernden Roboterphantasien im Gegensatz zum Klon stehen. Der Roboter ist eine Figur, die (im weitesten Sinne) die Arbeit erledigt und insofern auf eine Utopie der Mühelosigkeit zielt, auf eine Befreiung des Menschen von der Fron. Dass der Arbeitsautomat Menschenform hat, ist in den meisten Robotergeschichten eher zufällig – beziehungsweise diese Form ist eine Art Wiederkehr des Verdrängten (der

Tatsache, dass realiter der Mensch arbeiten muss – er müsste es um so verzweifelter, je größer das maschinelle Arbeitsvolumen ist, bei dem er nicht mehr benötigt wird). Auch wenn das Robotische immer wieder in niedliche oder unerbittlich bedrohliche Menschenformen einmünden will (Star Wars oder Terminator), könnten die robotischen Funktionen »eigentlich« auch in anderer Gestalt ausgeübt werden. Aber über diese Logik setzt sich die bilderschaffende Phantasie mit gutem Grund hinweg, denn sie zeigt tatsächlich künstliche Menschen, insofern sie sehnsüchtig abgespaltene Teile des realen menschlichen Lebens zeigt.

Im Grunde sind all diese Figuren so etwas wie ferne Nachfahren der ägyptischen Ushebtis. So heißen die kleinen Figürchen, die in den Vitrinen der ägyptologischen Museumssäle meist nur von flüchtigen Blicken gestreift werden – unscheinbare Fayencekerlchen in Mumienform, insofern doppelgängerische Abbilder des Toten. Sie dienen dazu, diesem im Jenseits die Arbeiten zu ersparen, zu denen ihn sonst die Gottheit heranziehen könnte, denn auch im Jenseits wollen die Felder bestellt sein. Deshalb trägt man der Figurine auf: »O du Ushebti, wenn ich verpflichtet werde, irgendeine Arbeit zu leisten, wie sie dort im Totenreich zu leisten ist, ... dann verpflichte du dich zu dem, was dort getan wird, zum Bestellen der Felder und zur Bewässerung der Ufer, zum Heranfahren des Düngers von Osten und Westen. ›Ich will es tun, hier bin ich‹ sollst du dann sagen.« So steht es im sechsten Abschnitt des Totenbuches. Die Zahl der Ushebtis in einem Grabe konnte bis zu 365 betragen – einer für jeden Tag des Jahres. Auch der Golem ist von Rabbi Löw erschaffen worden, damit er in der Synagoge die groben Arbeiten verrichte. Da, wo nicht – das ist die älteste, kindlichste Stufe dieses Wunsches – aus geheimnisvoller Neigung irgendwelche wimmelnd fleißigen Naturwesen die Arbeit übernehmen (»Wie war zu Köln es doch vordem ...«), muss das Ingenium die Menschenarbeit in phantastisch abgetrennter Gestalt auftreten lassen. Hierher gehören eigentlich auch all die bizarren Erfindungen der Sciencefiction, bei denen der Menschenleib erweitert, bestückt, aufgeladen, in seinen Möglichkeiten gesteigert und verschärft wird. Die SF hat hier ein unübersehbares Arsenal an mensch-maschinellen Halbzeugexistenzen geschaffen; Kampfmaschinen sind dabei häufig. Und im Grunde ist noch die wildeste Bricolage am menschlichen Körper, welche die Sciencefiction vorführt, Prothetik, bis hin zu den Umarbeitungen des Nervensystems in William Gibsons Neuromancer (»her reflexes ... for combat«): sie unterscheidet sich nicht wesentlich von der Hakenhand von Captain Hook oder dem ordinärsten Holzbein. Es handelt sich um Ergänzungen und genial opportunistische Verformungen des Leibes, auch wenn diese innen im Nervensystem getragen werden – ja, all diese Accessoires, auch die Instrumentalität der bewusstseinsverformenden Drogen à la Burroughs, lassen in gewisser Weise den alten Kern der Körperidentität nur um so schärfer hervortreten.

Die ganzen Konfigurationen des arbeitenden Maschinenmenschen sind also – seien sie auch von unendlicher Komplexität, voller Magie, Räderwerke oder Schaltkreise – in ihrem Grunde sehr einfach: externalisierte Arbeit (oder, um das der Vollständigkeit halber zu erwähnen: projizierte Erotik). Die neue biologische Kunstfigur dagegen wirkt an der Oberfläche zwar unendlich einfach (tout comme chez nous), aber sie birgt einen Strudel von (moralischer) Komplexität, der ihre schlichte Schafsphysiognomie als bloße Maske trügerischer Einfalt entlarvt. Der Android nämlich, der Fleisch vom Fleische eines Menschen ist, verkörpert eine wesentlich andere Utopie: nicht Ruhe von der Arbeit, nicht freie Lebenszeit, sondern Unsterblichkeit.

3. »Ich zog ein kleines, aber dickes Magazin mit extravagantem Titel aus der Tasche, auf dessen Umschlag ein Mann, ein Roboter und eine etwa albatrosgroße Fliege miteinander rangen. Ich schlug es bei einer Geschichte auf, die mich interessierte: Sie handelte von einem Mann (einem anderen als dem auf dem Umschlag), dem es gelungen war, sich die Methode – bis dahin wesentlich bescheideneren Lebensformen vorbehalten – der Fortpflanzung durch Spaltung anzueignen. In dem Moment, da ich meine Lektüre unterbrochen hatte, waren fünfhundertzwölf identische Personen vorhanden, die über die Situation nachdachten, welche sich ergeben würde, wenn sie in zehn Minuten zu tausendvierundzwanzig werden würden. Sie befanden sich in einem kleinen Raumschiff, das sie bereits bis in die Luftschleusen füllten, zwischen zwei Planetensystemen in der Konstellation Boötes.« *Kingsley Amis, That Uncertain Feeling*

Das Eigenartige ist, dass die Roboterphantasie vom künstlichen Menschen, die ihrem maschinellen Wesen nach doch zur Unkörperlichkeit tendiert, entschieden stärker sexuell aufgeladen scheint als das leibhaftige Cloning. Der häufigen Comics-Bilder von vögelnden Robotern und der »Junggesellenmaschinen« bedürfte es gar nicht als Beweise. Die Konstruktion des Roboters hat teil an einer manipulativen, masturbatorischen L'Eve future-Erotik, am Pygmalionrausch des Konstrukteurs. Die erotisierten Maschinen wiederum haben (sozusagen) ihren Orgasmus im Augenblick des Zusammenbruchs, wenn Olympia nicht mehr weitersingt und der genarrte, aus seinem Liebestraum auffahrende Betrachter erkennt: »Une automate...!« Um den Automaten herum findet ständig ein geheimes erotisches Ballett statt.

Beim Klonen handelt es sich dagegen um »asexuelle Reproduktion« – J.B.S. Haldane, der das Wort geprägt hat, nahm seinen Stamm vom griechischen *klôn* – der Zweig, das Pfropfreis. Das Klonen ist eine Angelegenheit, deren Logik eher dem Pflanzenreich anzugehören

scheint als der Fortpflanzung der Säugetiere – deshalb umgibt es nur ein klinisches Schweigen. Keine erregten Ästheten, keine ehrgeizgeschwellten verrückten Wissenschaftler zeugen ein vor libidinöser Besetzung vibrierendes Objekt – hier findet sich der Adam, aus einem unschuldigen und präerotischen Schlaf erwachend, eines Stückchens Körpersubstanz beraubt, und neben ihm ruht sein Doppel, ein Ableger, etwas wie eine Pflanze. [Die asexuelle Reproduktion könnte übrigens auch in einen bestimmten radikal gesellschaftskritischen Kontext gehören: Der klassische Feminismus hat schon früh als programmatische Forderung »die Befreiung der Frauen von der Tyrannei der Fortpflanzung durch jedes nur mögliche Mittel« gesetzt.]

Die vegetabile Menschenform hat eine eigene Geschichte in der phantastisch-utopischen Literatur; sie trägt – naturgemäß – stets die Signatur des Asexuellen. Meist geht es da satirisch-sentimentalisch zu wie bei Münchhausens Mondabenteuer, wo in unschuldigem Tonfall eine Existenz ohne Lust und Qual der Triebe geschildert wird: »Die Freuden der Liebe sind im Monde gänzlich unbekannt; denn ... es [gibt] nur ein einziges Geschlecht. Alles wächst auf Bäumen, die aber nach ihren verschiedenen Früchten auch an der Größe und den Blättern sich sehr voneinander unterscheiden.« Alles ist leicht und luftig, und die Mondpflanzenmenschen vergehen denn auch im Tod wie Rauch. Diese Leichtigkeit scheinen sie der Geschlechtslosigkeit zu verdanken. Aber gelegentlich nimmt die pflanzlich wachsende Menschenform auch Züge des Albtraums an. Die Leichtigkeit des Wachstums wird zu etwas unberechenbar und unterdrückbar Wucherndem.

Der *locus classicus* ist Jack Finneys Roman *Invasion of the Body Snatchers*, eine Horrorphantasie, in der sich einige Bewohner einer amerikanischen Kleinstadt nach und nach umgeben sehen von perfekten Kopien ihrer Nachbarn, außerirdischen Invasoren, deren jeweilige Austauschidentität in riesigen Pflanzenkapseln in den Kellern der Häuser heranreift. Die Verfilmung von Don Siegel, eines der klassischen B-Pictures, endet mit dem beklemmenden Bild, wie Kevin McCarthy, der letzte Unausgetauschte, bei der Flucht aus dem Städtchen auf einem belebten Highway versucht, einen Wagen anzuhalten, um Hilfe zu holen, und der massenhafte Verkehr an ihm mit einer Gleichgültigkeit vorbeibraust, welche die Frage, ob die Insassen der Autos auch schon vegetabile Kopien sind oder nur Menschen, die seine Verzweiflung ignorieren, fast überflüssig macht: Es kommt auf eins hinaus.

4. »... wohingegen die eigentliche Wiederholung nach vorwärts erinnert wird.« *Søren Kierkegaard, Die Wiederholung*

Der geklonte Kunst / Natur-Mensch stellt die ewige Wiederholung einer Tautologie dar, die wuchernde Nachinszenierung derselben organischen Individualität. Die Roboter mögen alle genau gleich aus der Werkstatt herausmarschieren, und doch verkörpern sie so wenig die Wiederholung, wie dies tausend Schraubenzieher vermöchten. Sie folgen dem Prinzip 1, 2, 3, 4…; der Klon trägt das Zeichen 1 = 1. Dieser Angriff gegen das, was im *Prinzip Hoffnung* Bloch mit einer problematischen Formulierung »die Macht der stärksten Nicht-Utopie« (des Todes) nennt, ist von ungeheuerlicher Einfachheit: das Ich wiederholt sich. Wir erleben hier die Re-Banalisierung der Wiederholung, welche seit Kierkegaard, Nietzsche und Duchamp zu einer Denkfigur von abgründiger Komplexität geworden war. Ist die Wiederholung in der Moderne als subversive Strategie eingesetzt worden, als paradoxer Talisman, mit dem man unter anderem den falschen Zauber der Einzigartigkeit des Kunstwerks austreiben und die schreckliche Besonderheit des Menschenlebens zum Bewusstsein zwingen wollte, so tritt nun als Wiederholung etwas völlig Blindes heran: das Säugetier im Zeitalter seiner technischen Reproduzierbarkeit. Die Unsterblichkeit kann insofern auch nicht mehr als Traum von Fülle sein, ein Pleroma, sondern sie wird zu einer leeren (höchstens noch durch den hilfreichen Zufall der Mutation zu durchkreuzenden) Unendlichkeit.

Die Versuche, das Vergehen des Körpers aufzuhalten, endeten bisher immer unweigerlich in den Katakomben der Groteske (schwarzer Humor; eine erzieherische, philosophische Form). Unternahm man allzu große Anstrengungen, die Individualität zu erhalten, so lag sie da wie Lenin im Mausoleum – Lenin, der offenbar zunächst deshalb einbalsamiert wurde, damit die Massen in endlosem Zug von ihm Abschied nehmen konnten. Aber nichts da! Ewige Anwesenheit. Doch die Mumie Lenins hat etwas Fahles, Gespenstisch-Ungesundes. Und genau dies (diesen kostbaren Rest von Geschichte und Tragikomik) wird die Schafsunsterblichkeit besiegen, die ja im Übrigen gar nichts anderes zu sein scheint als der Superlativ von Gesundheit, jener Gesundheit, deren naive Fetischisierung in unserer Gegenwart so peinliche Züge angenommen hat. In der Vergötterung des Gesunden (nicht im nüchtern negativen Sinn als Freiheit von Beschwerden, eine Freiheit, für die man den medizinischen Fortschritt segnet – sondern im debil strahlend positiven Sinn: gut drauf, sehr gut drauf, tadellos attraktiv) treffen sich in eigenartiger Weise die Bestrebungen fiskalisch havarierender Regierungen mit denen der New-Age-Konsumenten, die zwar von einem reinen Energiekörper träumen (eine immer von Defekten gefährdete Leiblichkeit verschwindet, wir werden alle machtvoll und mitfühlend unsichtbar), aber sich vorläufig mit einer makellos energischen und ebenmäßigen Physis begnügen würden. Die soziale Stigmatisierung des Ungesunden, die unter Gesichtspunkten der Konsumästhetik und der

Kostenrechnung den völkischen und sozialdarwinistischen Hass auf das Schwache wiederkehren lässt, dürfte sich mit den weiteren Fortschritten der Genetik ganz besonders zuspitzen – wenn Frauen es dann noch wagen sollten, Kinder zu gebären, die nicht von vollkommener Gesundheit sind! Und gehen wir den kleinen Traum-Schritt vom Tier zum Menschen weiter, dann wird man nicht nur gesund sein, »man« kann dann auch, stößt die Gesundheit schließlich doch an die Grenze des Todes, immer wieder kommen. Tod, wo ist dein Stachel? Aber ist das »Ich« denn einfach biologisch zu verdoppeln? Bedarf es zu einem »Ich« nicht neben der Natur auch einer Lebensgeschichte? Die Frage scheint schon in den Hintergrund abgeschoben (was der gegenwärtigen intellektuellen Mode entspricht, den Genen bei der Prägung der Lebensgeschichte vor allem, was »in und um uns wandelt«, den absoluten Vorrang einzuräumen), aber die sensationslüsterne Fabel eines kleinen, vor zwanzig Jahren erschienenen Romans darf sie rasch noch einmal stellen.

5. »Ov'è mio figlio?…« *Il Trovatore* »Alle Welt – sprach launig Pomponace – hofft auf Unsterblichkeit, wie ein Maulesel sich nach der Fortpflanzung sehnt, die ihm doch nicht zuteil wird…« *Julien Offroy de La Mettrie, Traité des Systèmes*

Die bisher vielleicht prägnanteste Formulierung des Mythems »Cloning« besitzen wir in einem mittelmäßigen Thriller. Im wuchernden Genre der Spionageromane gibt es ein spezielles Unterfach: die Nazi-Schauerromantik mit Titeln wie *The Valhalla Exchange* oder *The Haigerloch Project*. Zu den seltsamsten Abkömmlingen dieser Form gehört der 1976 erschienene Roman *The Boys from Brazil* (Die Boys aus Brasilien, 1992) von Ira Levin. Er zeigt kaum etwas von der stilistischen Meisterschaft, die Levins Kriminalroman *A Kiss Before Dying* (Der Kuß vor dem Tod, 1991) zu einem Klassiker gemacht hat; kaum etwas von der outrierten Phantasie von *Rosemary's Baby*. Doch in der Konzentration auf die mechanische Abwicklung seines mythischen Plots arbeitet er eine absurde Vision klar heraus: Aus genetischem Material, das der Führer noch zu Lebzeiten für das große arische Heilsprojekt gestiftet hat, wird ein knappes Hundert Knaben geklont, das nun seiner apokalyptischen Bestimmung entgegenwächst, mit einem zweiten Versuch zur Befreiung des Planeten von den Untermenschen zu beginnen. (Das entspricht ihrer Natur.) Levins Roman versucht nun, den elementarsten Einwand abzufangen: Spielen denn die jeweiligen Lebensumstände dieser genetischen Ebenbilder keine Rolle? Das Detektivproblem, das sich in den ersten Kapiteln stellt, lautet deshalb: Warum wollen Dr. Mengele und eine mächtige Organisation alter Nazis vierundneunzig mittlere Beamte im Alter von fünfundsechzig Jahren in verschiedenen Staaten Nordeuropas und in den USA und Kanada töten? Antwort: Dies sind die Stiefväter jener arischen Hoffnungsträger, deren häusliches Ambiente dem des

Alpha-Ideals möglichst genau entspricht, und die müssen möglichst exakt zu dem Zeitpunkt umkommen, da Hitlers eigener Vater starb. (Der sozialpsychologische Auslöser.) Vielleicht kommen ein paar durch. Vielleicht einer, das reichte ja.

Auf dem Grunde dieses schlechten Romans bleiben unter aller wirren Geschmacklosigkeit ein, zwei Gedanken liegen. Nicht, dass das Klonen von Hitler schon vor zwanzig Jahren im Klappentext als ein Albtraum beschrieben wurde, der »all too possible« sei, ist interessant; der Gedanke ist es, dass zum Klonen eine Art supplementäres Programm gehört, ein gesellschaftliches Stereotyp als Nährboden (definierte Familienkonstellation und soziale Stellung der Eltern). Damit hat Levin wenigstens andeutungsweise dargelegt: Dem Klonen entspräche als folgerichtige Ergänzung der grobe Nachbau des sozialen Umrisses, der das Original charakterisiert hatte. Ist dies nun als eine komplizierte Erschwernis eine Sicherung gegen die Realisierung aller Träume von Ich-Multiplikation, oder deutet es an, dass das Klonen Techniken sozialer Modellierung nach sich ziehen muss?

6. »Aber die drei Gehilfen beunruhigen mich. Wo sind Sie? Was treiben sie? Das ist die Frage. Sie haben das Rezept der Operation... Klotz-Lerne hatte trotz seiner Niederlage mehrere Menschen angetroffen, die seine teuflische Operation aushalten und die Seele eines anderen dafür eintauschen wollten. Die drei Deutschen vermehren jeden Tag die Menge jener Elenden, die nach Geld, Jugend oder Gesundheit lüstern sind. Die Welt weiß nichts davon: doch gehen Männer und Frauen um, die nicht sie selber sind... Ich trau dem Schein nicht mehr... Manchmal, wenn ich mich mit einem Menschen unterhalte, ist ein fremdes Licht in seinen Augen...« *Maurice Renard, Le docteur Lerne*

Solange noch ein fremdes Licht in den Augen der Operierten stand, schien nicht alles verloren; die Horrorvisionen der alten Phantastik geben angesichts der behaglichen Einförmigkeit, die uns jetzt die Genetik verspricht, einen stimulierenden Kontrast ab – das monströse Andere ist weniger bedrohlich als das unendlich identische Normale. Die Lüsternheit nach »Geld, Jugend oder Gesundheit« scheint im Fluchtpunkt des Bedürfnisses aufgehen zu wollen, immer und ewig zu sein wie man selbst.

Bestimmte Formen genetisch programmierter Labormäuse sind bereits patentiert; ich nehme an, dass auch jenes Schaf in seiner Besonderheit urheberrechtlich geschützt ist. Wird die Warenförmigkeit des genetischen Produkts einmal auf den Menschen übergreifen? Die Visionen einer nach beliebigem Bild geformten und nach solchem Bilde unendlich wiederholbaren Menschheit haben einst in der Regel ausgemalt, dass die Redupli-

kation im Interesse der Herrschenden geschieht und optimierte Untertanen erzeugt: Sklaven, Soldaten, Arbeiter. Die biologische Technik wurde als willkommenes Instrument totalitären Zwanges oder bürokratischer Manipulation eingestuft. Das herrschende Interesse heute würde staatlich möglicherweise durchaus auf knackig gesunde Individuen zielen, die unsere Krankenversicherung nicht belasten, aber damit im Grunde auch nur das längst verinnerlichte, private Interesse der Individuen selbst artikulieren. Die Genetik wird irgendwann – wahrscheinlich wird man sich so rasch gar nicht umsehen können – eine Liaison mit der Mode eingehen. Wenn man eine Gesellschaft, in der Generationen von Kindern tendenziell die vier oder fünf gleichen Vornamen tragen – Kevin beispielsweise –, mit den Möglichkeiten eines radikalen Körperstylings ausstattet, bedarf es keiner satirischen Anstrengung, sich die Folgen zu vergegenwärtigen.

7. »TITHONVS ... Aurora liebte ihn so sehr, daß sie sich auch von den übrigen Göttern ausbath, er möchte nicht sterben. Weil sie aber dabey vergaß, daß er auch in seiner jungen Lebhaftigkeit bleiben möchte, so wurde er zuletzt so alt und schwach, daß man ihn von neuem in eine Wiege legen und wie ein kleines Kind warten mußte. Er bath hierauf endlich die Aurora selbst, sie möchte doch verschaffen, daß er die Unsterblichkeit ablegen könnte. Allein, da sie ihn solcher Bitte nicht gewähren konnte, so verwandelte sie ihn dafür in eine Heuschrecke.« *Benjamin Hederich, Gründliches mythologisches Lexicon*

Zu diesem leicht surrealen Auszug aus der griechischen Mythologie wäre nur noch Helmut Heissenbüttels berühmte Schlussformel hinzuzufügen: »Mehr ist dazu eigentlich nicht zu sagen.« Ein schönes viktorianisches Gedicht – *Tithonus* von Tennyson – hat versucht, dieses Bruchstück der griechischen Göttersage zu der poetischen Einsicht zusammenzufügen, welche nun zwingender scheint denn je: dass der unsterbliche Menschenkörper etwas Grauenhaftes ist. Und er ist es auch in der Form, die für Tennyson nicht auszudenken war: der einer fröhlichen lebenskräftigen unbegrenzten Wiederholung. Kommt das denn nun wirklich »auf uns zu«? Und ist der tendenzielle Verlust der biologischen Singularität des Individuums eine Art neuer kopernikanischer Wende, wird der Mensch – nachdem er den Mittelpunkt des astronomischen Universums und die vom Tierreich streng getrennte Stelle hat verlassen müssen, nachdem ihm nachgewiesen worden ist, dass die Ökonomie sein Leben regiert und dass sein Bewusstsein nicht Herr im eigenen Hause ist – nun auch aus der dürftigen Rückzugsposition einer unverwechselbaren materiellen Identität vertrieben? Diese Aussicht scheint nicht die Kraft zu besitzen, besondere Beunruhigung freizusetzen. Insofern sie überhaupt mehr als ein Achselzucken auslöst, scheint sich hinter lautstarken, aber unklaren »humanistischen« Einwänden eher neugie-

riges Interesse breitzumachen – es ist, als eröffne sich eine Chance. Sollten wir denn alle wiederkommen, noch einmal und noch einmal? Statt des Grauens vor solch ahasverischer Existenz tritt vielleicht ein paradoxes Gefühl der Erleichterung ein bei der Ahnung, dass der Mensch irgendwann einmal nicht mehr den Gedanken einer zeitlichen Einmaligkeit denken müsse. Es scheint das Cloning nur eine weitere interessante New-Age-Möglichkeit, das kostbare Eigenleben zu perpetuieren, ein Angebot kosmischen Konsums. Man überrennt das Unbehagen am principium individuationis fröhlich rückwärts. Wer das Bedürfnis nach unendlicher Reproduktion der eigenen Individualität, den Hunger nach Unsterblichkeit nicht teilt, wer den Wunsch nach persönlicher Fortdauer per saecula saeculorum (der vielen als das Natürlichste überhaupt zu gelten scheint) töricht findet, kindisch, auch von einer gewissen vampirischen Unheimlichkeit (deren zwielichtiger Glanz aber doch bald wieder im selbstgewissen Grinsen erlischt), sieht diesen ersten Regungen einer Identitätsindustrie verlegen und ratlos zu. In einigen seiner Briefe skizziert E.T.A. Hoffmann nebenbei ein interessantes Konzept: der Automat als Philister. Diese Linie ließe sich verlängern, mit noch ungleich schärfer zugespitzter Pointe: der Klon als Spießer, die neue Unsterblichkeitsfigur als absolute Peinlichkeit. Sind wir diesem abgründigen Sonderangebot der Zukunft wirklich ausgeliefert? Da, wo der Einspruch des Ethos so hilflos versagt wie der des guten Geschmacks, bleibt nur die weiße Magie einer apotropäischen Geste – eines Zitats aus der großen Dichtung. Swinburne hat geschrieben:

From too much love of living, / From hope and fear set free, / We thank with brief thanksgiving / Whatever gods may be / That no life lives forever; / That dead men rise up never; / That even the weariest river / Winds somewhere safe to sea.

Joachim Kalka

Vom Autor gekürzte Fassung der Erstveröffentlichung in »Kursbuch 128, Lebensfragen«, Rowohlt Berlin, Juni 1997.

Bibliografische Notiz

Kingsley Amis, Ending Up, London 1974. William Gibson, Neuromancer, London 1984. Kingsley Amis, That Uncertain Feeling, London 1955. Harald Szeemann, Junggesellenmaschinen / Les machines célibataires, Bern 1975. Gottfried August Bürger, Wunderbare Reisen zu Wasser und Lande, Feldzüge und lustige Abenteuer des Freiherrn von Münchhausen (1788), Stuttgart 1969. Jack Finney, Invasion of the Body Snatchers, New York 1956. Don Siegel, A Siegel Film, London 1993. Søren Kierkegaard, Die Wiederholung (1843), in: Die Krankheit zum Tode und anderes, hrsg. von Diem / Rest, Köln 2 / 1968. Ira Levin, The Boys from Brazil, New York 1976. Maurice Renard, Le docteur Lerne, sous-dieu, Paris 1908.

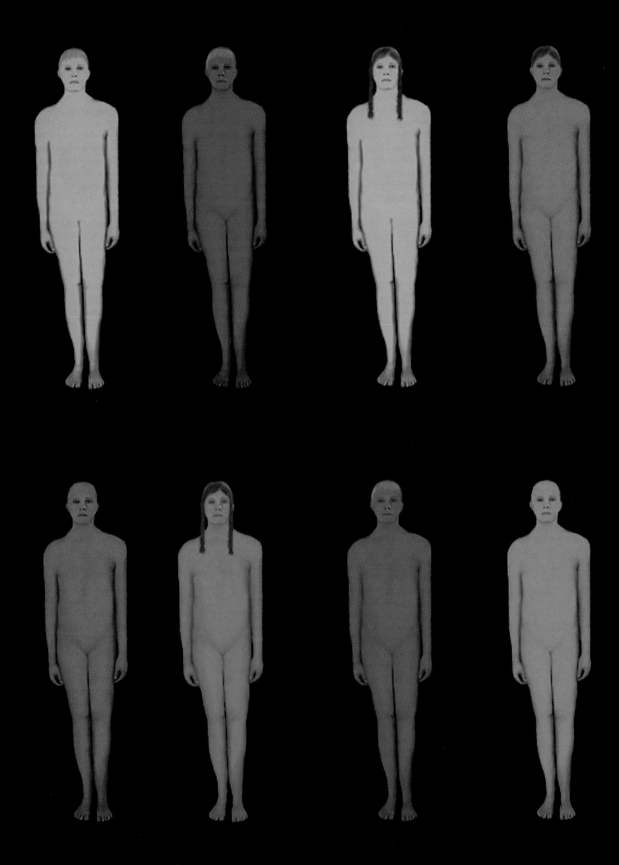

DREAMS OF THE BODY

Of Sheep and Men

1. »1973«, he said reflectively. »I find the years are sounding more and more odd. 1973 sounds like a thing out of those comics, with death-rays and robots and monsters from outer space. Whereas the year I was born in sounds like stage-coaches and highwaymen and crinolines and fans and duelling-pistols and warming-pans and snuff-boxes and ruffles and shoe-buckles and ...« *Kingsley Amis, Ending Up*

2. A sheep has been cloned; result: two sheep (»The same ones? « – »Whaddya mean – the same ones?!«, as Karl Valentin and Liesl Karlstadt bicker). The news – followed immediately by other news concerning monkeys and the enthusiastic offers from the ranks of our own species to be next, please – lead, apart from the first attempts to get in line for the treatment, to a vague feeling of disquiet. But this is all. Haven't we heard that news a long time ago? These are dreamed-of possibilities. Like similar catastrophes of cognition this one has been anticipated by the fantasies of genre narration so often that its actual happening may still be vaguely irritating, but at the same time it is, somehow, old hat. Maybe this ambiguity only means that the news are undecipherable. If, looking through the small tear this contradiction opens in the fabric of habit, we consider some literary fantasies of past centuries (and our century is past, too, more or less), then we might get some food for thought about this novelty and about all the other headlines, rumours and listless discussions about the trade in human organs, deep-frozen semi-cadavers awaiting a cure for the as yet incurable, genetic adjustments and foetal selection. We must think about it as well as we're able to – without really daring to hope that our moral imagination will ever catch up with our technological possibilities. So, searching for clues, we may as well fumble around the labyrinth built from old magic-lantern slides out of fairytales, comics and sensational magazines. This latest invention looks so much like an image from a forgotten fantastic movie that it might be interesting to compare it with some genuine precursors. Maybe some kind of iconographical approach might well be the best one for something which seems so closely linked to the aesthetics of gray old magazine illustrations.

The new technology in a strange way confounds the clean opposition between the artificial and the natural. Behind the innocent gaze of the Scottish sheep immediately appeared the phantom shape of the first human clone. Would he, who couldn't, after all, be denied the status of a natural being, yet be »artificial«? Would he, considered within a topography of the fantastic, join the ranks of all those automata and androids which we shall call, for brevity's sake, robots – »externally« created by man, even if they are homunculi? It is obvious that another familiar figure of the fantastic is more relevant here: the double.

The clone is a multiplication of one's own identity out into the space of the »Other«, a subversion of the Other by »Me«, an usurpation of the space of the Non-Me. Everybody has the same face, and from the point of view of the alpha-being this face is his own. All around himself he looks into mirrors. The double in mirror images and shadows, in all its forms which haunt the fairy-tales and the ethnological monographs, always has been a threatening apparition – superstitiuous awe of doubling can be, in early societies, so virulent as to lead to the killing of twins. The new double which peers over our horizon seems at first to be almost jolly, somehow it is smooth and harmless – sheepish, in short. Soothing. The European Parliament has passed its first resolution against the cloning of human beings, with passionate »humanist« helplessness. But it will hardly succeed in convincing a public so interested in the multiplication of, say, Boris Becker that this technology might contain a threat. A threat? Baa. Of course it is merely accidental that the first embodiment of this new principle in the mammalian world has been a sheep, but accidents are surely meant to be taken symbolically if they are that brazen.

In past times the figure of the double was indeed fearsome since it threatened to dissolve individuality. Now individuality will double itself or multiply into infinity – which seems to mean not a dissolve but a solidification, a rush of new power. Multiplication seems against all logic to strengthen one's individuality (or at any rate what one takes for it). This is the triumph of a Narcissus no longer seduced by his mirror image (something paradoxically other and always slightly eerie), but ordering his indistinguishably identical mirror images to march out into the world as comfortable copyright properties, like troops, like ubiquitous agents of his self-indulgence. If one sorts through the forms of artificial human beings our imagination has created, comparison soon shows that all the ambiguous robot fantasies are different from the myth of the clone. The robot is a figure which does our work; imagining this figure aims at a utopia of toil abolished – man will be free from all enforced strenuous bodily effort. That the robot appears in human shape is in most

robot tales a mere convention – or something like the return of the repressed (of the fact that in our reality man has to work – all the more desperately the bigger the volume of automatic work is which doesn't need him any more). Even if the robotic fantasy all the time tends to coagulate in cute or terrible human shapes (Star Wars or Terminator), the robots could basically function in quite different forms. This, though, is ignored by our imagination, and for a good reason – it shows us artificial men, because we are shown nostalgically dissociated parts of human life. At bottom all these figures are something like late descendants of the Egyptian ushebtis. This is the name for the tiny figurines for which we usually only spare a quick absent gaze when we meet them in their glass cases in the museums – drab little fayence mummies, doubles of the dead person. They have been created to free the dead from all the heavy work the gods might demand from them in the hereafter, for even in the other world the fields must be tilled. Therefore the little figure receives its orders: »O thou ushebti, if I shall be bound to any work in the realm of the dead ... then thou shalt bind yourself to these tasks, tilling the fields and watering the riversides ... I will do it, here I am, that is what thou shalt say.« This is what we read in the sixth part of the Book of the Dead. The golem also has been created by Rabbi Löw to take care of the heavy work around the synagogue. If some astonishingly industrious elementals won't do our work out of secret inclination (the Heinzelmännchen of Cologne), our imagination must lend a fantastically externalized shape to human labor. This goes for all the bizarre inventions of SF where the human body is extended, loaded, charged with powers – even the wildest bricolage tinkering with the human body remains at bottom a simple prothetic operation, not excluding all the renovations of the central nervous system in William Gibson's Neuromancer (»her reflexes ... for combat«). All this in the end doesn't really differ from Captain Hook's hand or from the most ordinary wooden leg – these are supplementations and ingeniously opportunistic deformations of the body, even if worn in our innards. In a way, all these accessoires, not excluding the consciousness-changing drugs à la Borroughs, only render the core of body identity more solid.

Thus all the configurations of the machine man that is put to work are very simple – even if they appear infinitely complicated, full of magic, little wheels or wiring. Their simplicity has one meaning only: externalized labour (or, to mention this in passing, projected eroticism). Our new biological artifice, though, appears on the surface infinitely simple (tout comme chez nous), but it contains a maelstrom of moral complexity and we must realize that its simple sheepish looks are a mere mask of innocence. The android which is flesh from a human being's flesh embodies a very different utopia – not that of cessation of labour, of a free life, but of immortality.

3. »I pulled from my pocket a small but thick magazine with an extravagant title and a cover showing a man and a robot and a fly about the size of an albatross all having a fight. I got it open at a story that interested me: it was about a man (a different man from the man shown on the cover) who'd managed to transfer to himself the process, hitherto available only to much humbler forms of life, of reproduction by fission. At the moment when I'd had to stop reading, there were 512 personages, all identical, considering the situation likely to arise when they became 1,024 in ten minutes' time. They were travelling in a small space-ship, which by now they filled to the air-locks, between two planetary systems in the constellation Boötes.« *Kingsley Amis, That Uncertain Feeling*

Enough the robot fantasy of artificial bodies, tending towards an aesthetics of the machine and therefore towards bodilessness, has a much higher sexual charge than cloning, which is sheer body. All those frequent comics pictures of screwing robots and all those »bachelor machines« hint at a manipulative, masturbatory L'Eve future-eroticism, at a Pygmalion ecstasy of construction. The eroticized machines on the other hand experience their orgasm, as it were, in breaking down, when Olympia doesn't sing any more and the naive lover is rudely torn from his dream, shouting »Une automate...!« Around the automaton there is, secretely, a continuous erotic ballet.

Cloning, on the other hand, is asexual reproduction. J. B. S. Haldane, who coined the word, took it from the Greek root *klôn* – the grafted twig. Cloning is a process the logic of which belongs to the vegetable kingdom rather than to mammalian reproduction – therefore it is surrounded by pastoral silence. No excited aesthetes, no ambitious mad scientists create an object vibrating from their libidinous projections – Adam, awaking from an innocent and pre-erotic sleep, finds himself robbed of an infinitesimal piece of body substance, and beside him lies his double, his branching-out, something like a plant. (Asexual reproduction, by the way, can appear as a desideratum within a certain context of radical social criticism: feministic utopias have long ago demanded »the liberation of women from the tyranny of reproduction by all possible means«.)

Vegetable humanity has its own history within fantastic literature; naturally it is always asexual. Mostly the images offered are satirical and sentimental as in Münchhausen's adventure in the moon, where an existence without lust and pain is described in innocent tones: »The pleasures of love are totally unknown in the moon, for... there is only a single sex. Everybody grows on trees, which are different by virtue of their various fruits but also through size and through the shape of their leaves... « Everything is light and airy, and the

moon people in dying drift away like smoke. This lightness seems due to their sexlessness. But elsewhere the human form which grows like a plant becomes the stuff of nightmares. The easy growth becomes an unpredictable and unrepressable vegetable tumor. The *locus classicus* is Jack Finney's novel *Invasion of the Body Snatchers*, a horror scenario which has some inhabitants of a small town in America gradually surrounded by perfect replicates of their neighbours, invaders from outer space, whose substitute bodies ripen in the basements of the little town in giant pods. The movie version by Don Siegel, one of the classic B-pictures, ends with the uneasy image of Kevin McCarthy – the last genuine man – flying from the town and trying to flag down help on the highway, where the busy traffic passes him with an indifference which makes it almost irrelevant if the passengers in all those cars are pod people or human beings ignoring his despair.

4. »…whereas genuine repetition is remembered forward.« *Søren Kierkegaard, The Repetition*

The cloned being, balanced between art and nature, represents an eternal repetition of a tautology, a rankly seeding growth of the same organic individuality. Robots may march out of the workshop looking perfectly alike, but they cannot embody the principle of repetition – no more than one thousand screwdrivers could. They follow the principle of 1, 2, 3, 4 … ; the clon carries the sign 1 = 1. Is this immortality? The attack against what Ernst Bloch called, with a problematical phrase, *in Das Prinzip Hoffnung* »the power of the strongest non-utopia« (death) is of terrific simplicity: the »I« repeats itself. We can watch the re-trivialization of repetition, an idea which since Kierkegaard, Nietzsche and Duchamp had become abysmally complex. If modernity had used repetition as a subversive strategy, a paradoxical talisman to drive out the false magic of artistic singularity and to force the horrible specificness of any human existence into our consciousness, now repetition appears as something utterly blind: the mammal in the age of mechanical reproduction. Thus immortality can no longer be a dream of fulfilment, of the pleroma, it becomes an empty infinity which only the helpful accident of mutation could enliven gain.

All attempts to stop the dissolution of the body have so far ended in the catacombs of the grotesque (black humour: an illuminating didactic form). If too strenuous attempts were made to preserve an individuality, it was lying there foolishly like Lenin in his mausoleum – Lenin, who at first had only been embalmed provisionally, so that the masses, in endless procession, could take their leave from him. But then it was decided otherwise: No leave-taking – eternal presence. Still the mummy of Lenin shows something livid, unhealthy, spooky. And precisely this (this precious little rest of history and tragicomic sanity) will be

overcome by our new sheepish immortality – which, by the way, seems to aim at being nothing else but the superlative of health, of that health we have fetishized so naively and embarrassingly in recent years. The idolization of health (not in the sober negative sense of freedom from pain, a freedom we bless medical progress for, but in the sense of a silly beaming poster aesthetic: let's be gorgeous, let's be without blemish, let's be utterly attractive) curiously links the fiscal interests of embattled governments to the desires of New Age consumers who may dream of a pure energy state but would settle for a fault-lessly perfect and energetic physis. This social stigmatization of anything unhealthy, where a perniciously silly consumer's aesthetic and the bureaucratic streamlining of a public service meet to reawaken a social darwinist hate of anything weak, will become more and more virulent with the progress of genetics – if any woman should dare to give birth to a child not in perfect health...! And if, dreaming and desiring frantically, we take the little step from animal to man, then we will not only be healthy, »we« can always, should perfect health finally meet with death, return as ourselves. Death, where is thy sting? But can we simply double ourselves, double our precious ego, biologically? Does an »I« not need, besides its nature, a history? This question seems unexciting – current in-tellectual fashion tends to see the influence of genetic equipment as vastly dominant in determining the history of a life, relegating all that Goethean »change« which »in und um uns wandelt« to unimportance. Remembering the sensational plot of a little novel which appeared some twenty years ago may raise the question once more.

5. »Ov'è mio figlio? ... « *Il Trovatore* »All the world – Pomponace quoth merrily – hopes for immortality, like a mule dreaming of that propagation which he'll never command...« *Julien Offroy de La Mettrie, Traité des Systèmes*

Possibly the most succinct variant of the cloning myth so far can be found in a mediocre thriller. Within the industrious genre of the spy novel there is a specialized subgroup: the Nazi thriller with titles such as *The Valhalla Exchange* or *The Haigerloch Project*. Among the strangest products in this category is Ira Levin's novel *The Boys from Brazil* of 1992. It exhibits little of the stylish virtuosity which made Levin's *A Kiss Before Dying* a classic, hardly anything of the outrageous imagination displayed in *Rosemary's Baby*. Yet the mechanically developed plot shows us a clearly defined mythical vision. Almost a hundred boys have been cloned from genetic material the Führer had donated before his death for the great project of ultimate Aryan victory, and these boys are growing towards their apocalyptic destiny: to start another attempt to liberate the planet from all its subhuman elements. (This, shall we say, is their nature.) Levin's novel tries to block the elementary

objection: Are the individual circumstances of these young lives irrelevant? Therefore the detective problem constructed in the first chapters is: Why do Dr. Mengele and a powerful organization of old Nazis want to kill off ninety-four modest officials in various states of northern Europe, the USA and Canada? The answer: These are the stepfathers of all those little Aryan messiahs, whose domestic environment had to approximate as closely as possible that of the alpha-ideal; therefore they must die exactly at the moment Hitler's own father died. (The socio-psychological trigger.) That's it, then. Maybe a few of the boys will get through. Maybe one will, that would be sufficient.

At the bottom of this silly novel one or two thoughts can be discovered buried under tasteless confusion. It is not that interesting that even twenty years ago the cloning of Hitler was described in a blurb as a nightmare »all too possible« – but the thought that cloning should include a kind of supplementary program, the fostering soil of a social stereotype (a precisely defined family constellation and social position). Thus Levin has at least hinted at the idea that cloning might have to include an attempt at rebuilding the social outlines of the original. Is this complication a safeguard against the realization of multiplicatory dreams or does it hint at a logical tendency: cloning must lead to techniques of social modeling?

6. »But the three assistants worry me. Where are they? What are they up to? That is the question. They possess the secret of the operation ... Those three Germans increase every day the number of those wretches greedy for money, youth or health. The world doesn't know it, but men and women are walking around who are not themselves ... I don't trust appearances any more ... Sometimes, when I talk with a person, there is a strange light in his eyes ... « *Maurice Renard, Le docteur Lerne*

As long as there was a strange light in the eyes of those who had been operated on, not everything had been lost: the horrors in the old fantastic novels offer a stimulating contrast to the cosy uniformity promised by genetic progress. The monstrous Other is less threatening than an infinitely identical normality. Even our greed for »money, youth or health« seems to dissolve in the vanishing point of the desire to be eternally the same, to be just like oneself.

Certain forms of genetically programmed laboratory mice have already been patented; I assume the sheep has also been copyrighted. Will the commodity form of these genetic products eventually invade human society? All the warning visions of a plastic, malleable

humanity have usually supposed that the reduplication of a fixed model would be urged at the insistence of a governing and exploitative class, that its reason would be the production of willing slaves, soldiers, workers. Biological technology was seen as a welcome instrument of totalitarian force or bureaucratic manipulation. Of course the state today will show an interest in elastically healthy individuals who won't be a burden on social security – but in supporting the technology it will only give voice to a desire felt much more fiercely by the individuals themselves. Genetics will pretty soon – probably with baffling speed – forge an alliance with fashion. If a society in which generations of children largely carry the same four of five topical Christian names (Kevin, for instance) is supplied with the means of radical body styling, it is not difficult to imagine the consequences.

7. »TITHONVS ... Aurora loved him so much that she asked the other gods that he should not die. Since she forgot to stipulate he might remain within his youthful liveliness, he got so old and decrepit in the end that he had to be put into a cradle again and nursed like a little child. Then he asked Aurora herself that she might bring it about that he could leave off immortality. Since she could not grant this wish she changed him into a grasshopper.« *Benjamin Hederich, Gründliches mythologisches Lexicon*

This slightly surreal extract from Greek mythology only needs Helmut Heissenbüttel's famous concluding formula: »There's no more to be said about this, actually.« An impressive Victorian poem, Tennyson's *Tithonus*, has tried to shape this fragment of Greek myth into the insight (which nowadays has become even more urgent) that the immortal human body is something horrible. And this also goes for a possibility Tennyson wasn't able to imagine: its merry, lively, unlimited repetition. Is this really what is »in store for us«? Is the approaching loss of the individual's biological singularity some new kind of Copernican turn, will man – after having to leave the centre of the astronomical universe and his place separate from the animal kingdom, after having it proved against him that economics govern his existence and that his consciousness is constantly invaded by an unruly unconscious – be chased from his precarious remaining defensive position, from an unmistakable material identity? This perspective doesn't seem to be very chilling. If its contemplation produces more than a shrug, there seems to be – behind the smokescreen of loud but vague »humanist« opposition – eager curiosity. It's like being granted an unexpected opportunity. Shall we all return, again and again? The horror of such an Ahasverian existence seems to disappear into paradoxical relief at the thought that man might be released from the necessity of facing one single and irreplacable life. Cloning

seems another fascinating New Age possibility to perpetuate one's precious existence, an offer of cosmic consumption. The uneasiness about the principium individuationis is simply shouted down. Whoever doesn't share the desire for infinite reproduction of one's own individuality, the hunger for immortality, whoever feels the wish for personal continuance per saecula saeculorum (which for many seems the most natural thing in the world) to be something foolish, infantile, tainted with a slightly vampirical eerieness (which soon evaporates, though, with a self-confident grin), will watch the first stirrings of an identity industry with helpless embarrassment. In his letters, E. T. A. Hoffmann sketches in passing an interesting concept: the automaton could be a philistine. We could follow this argument and arrive at a much sharper punchline: the clone as a boor, the new immortality as something absolutely vulgar. Are we really helpless before this special offering from the abysmal future? Where ethical argument fails as well as the disgusted mutterings of good taste, we are left with the white magic of an apotropaic gesture – a quotation from great poetry. Swinburne wrote:

From too much love of living / From hope and fear set free, / We thank with brief thanksgiving / Whatever gods may be / That no life lives for ever; / That dead men rise up never; / That even the weariest river / Winds somewhere safe to sea.

JOACHIM KALKA

This is a version, shortened by the author, of an essay
first published in »Kursbuch 128, Lebensfragen«,
Rowohlt Berlin, June 1997. Translated by the author.

Bibliographical note

Kingsley Amis, Ending Up, London 1974. William Gibson, Neuromancer, London 1984. Kingsley Amis, That Uncertain Feeling, London 1955. Harald Szeemann, Junggesellenmaschinen / Les machines célibataires, Bern 1975. Gottfried August Bürger, Wunderbare Reisen zu Wasser und Lande, Feldzüge und lustige Abenteuer des Freiherrn von Münchhausen (1788), Stuttgart 1969. Jack Finney, Invasion of the Body Snatchers, New York 1956. Don Siegel, A Siegel Film, London 1993. Søren Kierkegaard, Die Wiederholung (1843), in: Die Krankheit zum Tode und anderes, ed. Diem / Rest, Köln 2 / 1968. Ira Levin, The Boys from Brazil, New York 1976. Maurice Reard, Le docteur Lerne, sous-dieu, Paris 1908.

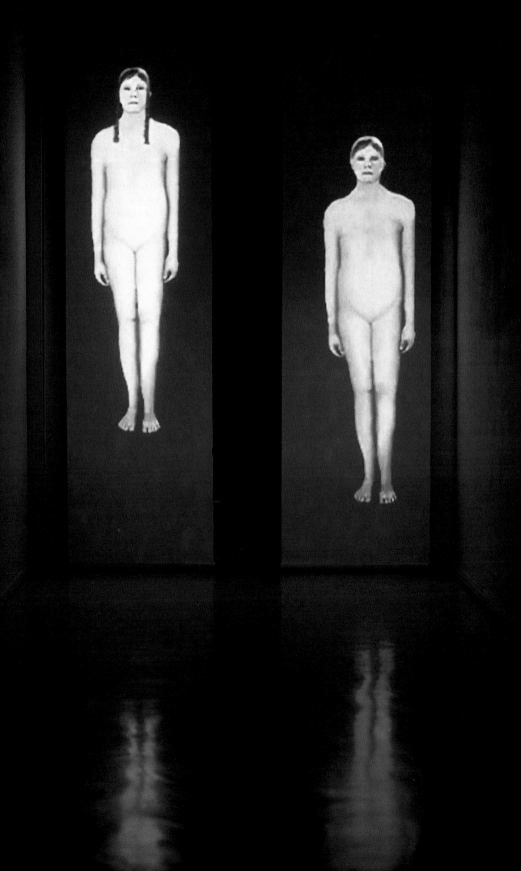

ARRIVAL – DEPARTURE

In der Videoarbeit »Arrival – Departure«, 1998, schließt die einfache und zunächst realistisch erscheinende Darstellung des Menschen jede Möglichkeit der individuellen Differenz aus. Zeichen der Unterscheidbarkeit, wie Haartracht und Farbe, verstärken nur noch den Eindruck vom bloßen Design des geklonten und geschlechtslosen Individuums. Die Körper besitzen keinen Bauchnabel und keine Brustwarzen mehr. Belebt scheinen die Figuren nur durch ein rhythmisches Atmen, das jedoch eher einem mechanischen Aufblähen gleicht. Nichts, was außer der äußeren, vom Computer generierten Form noch auf eine menschliche Herkunft hindeutet. Die Körper scheinen aus dem Nichts zu fallen und wieder dahin zurückzukehren. Die Arbeit entstand ursprünglich für das Foyer des Ministeriums für Wissenschaft und Kultur in Hannover.

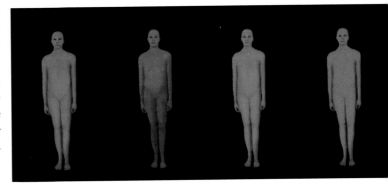

In the video »Arrival – Departure«, 1998, the simple and initially realistic-appearing depiction of a person rules out any possibility of individual difference. Signs of distinguishability, like hairstyle and color, only intensify the impression of the mere design of the cloned and sexless individual. The bodies no longer have navels or nipples. The figures seem alive only due to a rhythmic breathing, which, however, more closely resembles a mechanical inflation. Nothing beyond the computer-generated external form remains to indicate a human origin. The body seems to fall out of nothingness and to return to it again. The work was originally created for the foyer of the Ministry of Science and Culture in Hanover.

BERND SCHULZ

Arrival – Departure 1998 (Installation Stadtgalerie Saarbrücken 2001)

SILVERCITY

In »Silvercity 1 + 2«, 1999, hat Melhus aus Originaltönen des US-Western *Billy the Kid* einen fiktiven Dialog gebildet. Dazu hat er Bildräume entwickelt, wie sie sich gegensätzlicher kaum denken lassen. In einem sieht man zwei Cowboys am Lagerfeuer, während im anderen zwei Astronauten in ihrer Kapsel um die Erde kreisen. Während das eine Bild, in dem die Figuren wie Pappkameraden oder Abziehbilder wirken, in gelegentlich seltsam antiquierter Sprache (die deutsche Synchronfassung wurde verwendet) den Westernmythos von Männerfreundschaft zu beschwören scheint, suggeriert der gleiche Dialog im anderen Bild Isolation und Einsamkeit. Der Versuch der einen Seite, in einen ehrlichen Dialog einzutreten und über ein Kindheitserlebnis zu sprechen, wird von der anderen Seite abgeblockt bzw. verdrängt. Die unterschiedlichen Bildräume scheinen sich wechselseitig zu kommentieren und die Frage nach dem wirklichen emotionalen Untergrund von Bildmetaphern zu stellen. Die Zwillingsmetapher in beiden Bildgeschichten steigert den Mythos vom einsamen Cowboy ins Groteske. Bild und Ton werden für den Betrachter eine Art innerer Dialog.

In »Silvercity 1 + 2«, 1999, Bjørn Melhus puts together a fictional dialogue from segments of the original sound track of the American Western *Billy the Kid*. He created image spaces for this whose contrast could hardly be greater. In one, we see two cowboys at a campfire, while in the other, two astronauts circle the earth in their capsule. In the one image, the figures seem like cardboard dummies or iron-on decorations. In a sometimes peculiar, antiquated language (the German dubbed version was used), it seems to invoke the Western myth of male friendship. In the other image, the same dialogue suggests isolation and loneliness. One side's attempt to enter into honest dialogue and to speak about a childhood experience is blocked or repressed by the other side. The different image spaces seem to comment on each other and to pose the question of the real emotional foundation of image metaphors. The metaphor of the twins in the two image stories amplifies the myth of the lonesome cowboy to the point of the grotesque. For the viewer, image and sound become a kind of interior dialogue.

BERND SCHULZ

SILVERCITY 1 *Silvercity ist weit weg* **/ SILVERCITY 2** *The End of the Beginning*

(…) Du bist kein Cowboy?

Was weiß ich …

Ich weiß selber nicht …
Weiß der Deibel! (Teufel)

Du Lausejunge!
Hör' doch auf und lass' uns pennen.

Schläfst du schon?

Nein, warum?
Was deine Anständigkeit betrifft,
verlass' ich mich auf dich wie du
dich auf mich.

Wer denn sonst wohl.
Wäre doch gelacht.
Hahahaha …

Hahahaha …

Feiner Kerl. 'n guter Freund?

Der Beste!

'n guten Freund auf
der einen Seite …

… und 'n guten Freund auf
der anderen Seite.

'n guten Freund auf der einen Seite …

… und 'n guten Freund auf der
anderen Seite. Das wär' so was!

Wieso? Was?

Einen Freund aus Silvercity!

Weiß der Deibel!
Erinnerst du dich?

Will nichts hör'n!

's war in Silvercity …

Silvercity ist weit weg!

Hmmhmm, Silvercity liegt weit weg.

Schläfst du schon?
Also, da war einer bei mir heute Nacht,
den kenn' ich noch von Silvercity, als wir
Kinder waren. Ich weiß selber nicht.
So was ist mir im Leben noch nicht passiert.
Ja …, damals in Silvercity.

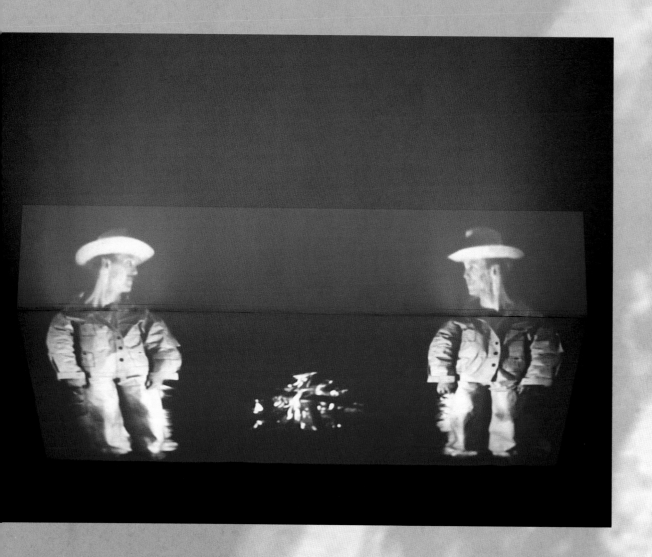

Silvercity 1 1999 (Installation Stadtgalerie Saarbrücken 2001)

Ja, und wenn du das mit zwölf
Jahren erlebst, kommst du so leicht
nicht mehr in die richtige Bahn.
Ja …, damals in Silvercity.
Hast dich gar nicht verändert.
Erinnerst du dich? 's war in Silvercity.
Erinnerst du dich?

Silvercity ist weit weg!

Hh, ja …, Silvercity liegt weit weg.
Ja …, damals in Silvercity.
Ich weiß selber nicht.
Ich bin noch genauso
häßlich wie damals.

Ganz recht!

Feiner Kerl.
Nimm mal den Hut ab.

Lass' man, ich hab' das gern.
Isser gut?

Ja, sehr gut.
Hör' doch auf und
lass' uns pennen.
Schläfst du schon?
Hmmhmm.

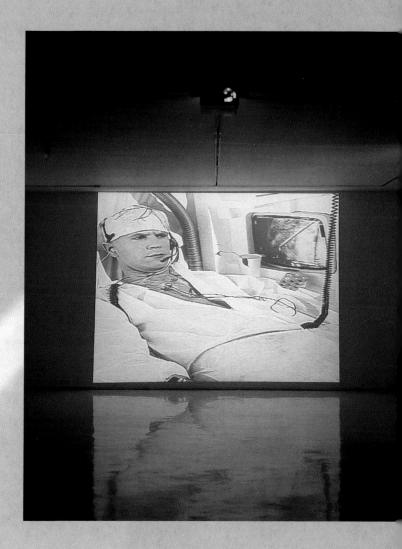

Silvercity 2 1999 (Installation Stadtgalerie Saarbrücken 2001)

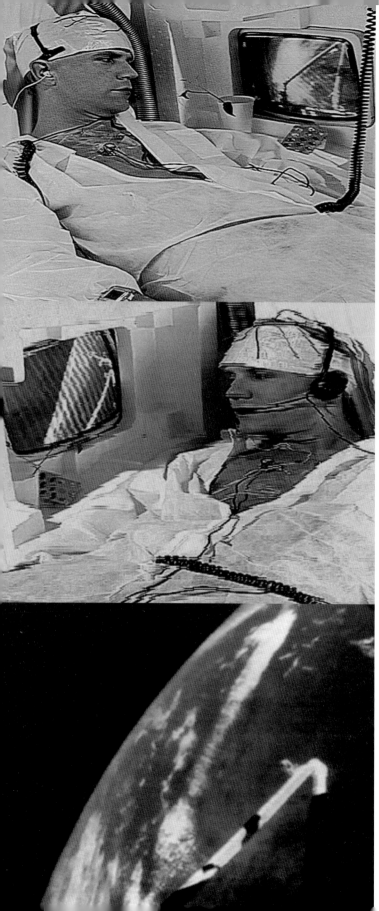

Weißt du noch?

Was willst du?!

Weißt du noch? Es war in Silvercity …

Na, dann pack' mal aus!

Das geht besser unter vier Augen.

Hhhh, also …

Sieh mal, du warst doch noch ein Kind,
als die dumme Geschichte passierte.
Erinnerst du dich?

Will nichts hören!

Will nichts gesagt haben!
Das hat schon mal einer zu mir gesagt.
Erinnerst du dich? Damals in Silvercity.

Silvercity ist weit weg!

Hhhh, ja …,
Silvercity liegt weit weg.

Hör' doch auf und lass' uns pennen.

Silvercity 2 1999

WIR SIND DOPPELT IN UNS SELBST

Michel de Montaigne, 1580

Zu Arbeiten von Bjørn Melhus

Die Leidenschaft, Medienwirklichkeiten nachzuspielen, begann mit fünf. Da spielte Bjørn Melhus mit seiner zwei Jahre älteren Schwester im Wohnzimmer Astronaut. Kurz nach der Mondlandung durch Apollo 11 fuhren die beiden unter einer Wolldecke durch den abgedunkelten Welt-Raum der häuslichen Umgebung. Hin und wieder schauten sie hinaus auf die Erde, die als Leuchtglobus in der Zimmerecke stand. Oder sie waren die *Raumschiff Enterprise*-Besatzung. Ereignisse, die die Medien transportiert hatten, aber auch Filmfiguren wurden nachgespielt, ebenso wie *Bonanza* oder *Fury*, die in den späten 6oer und frühen 7oer Jahren zum medialen Alltag heranwachsender Kinder gehörten. Die Helden einer damals in Deutschland noch überschaubaren Medienwelt bestimmten die Gesten, die Sprache und die Moden einer Fernsehgeneration, die im Banne des Bildschirms aufgewachsen ist.

Von Theodor W. Adorno bis Neil Postman ist das Phänomen der Mediatisierung der Gesellschaft durch das Eindringen des Fernsehens nach dem Zweiten Weltkrieg analysiert worden.[1] Günther Anders und John Fiske, Richard David Precht und Heribert Seifert haben seit den 5oer Jahren bis heute das Medium und seine Wirkung als Kommunikations- und Erfahrungsersatz beschrieben.[2] Der Mensch verwandelt sich vor dem Bildschirm in den Konsumenten einer Massenware, die kaum noch zwischen Unterhaltung und Information, Werbung und Imageprägung, Wahrheit und Fiktion unterscheidet. Das Massenmedium, das rund um die Uhr »Fertigbedeutungen« (Fiske) frei Haus liefert und uns »chemisch gereinigte« (Anders), also mediengerechte Berichte auftischt, hat das Erleben der realen Welt scheinbar überflüssig gemacht.

Bjørn Melhus gehört zu jener Generation, die ihre Identität in Zwiesprache mit dem Fernsehen als Fenster zur Welt aufgebaut hat. Seit über zehn Jahren reflektiert der Künstler mittels des Mediums über das Medium. Aus dessen assoziativen Fragmenten baut er neue Fabeln und Märchen als Mediencollagen aus eigenen Bildern und geliehenen Stimmen zusammen. In Videos, Filmen und Installationen setzt er sich mit seiner Medien-

erfahrung auseinander und fragt: »Wer bin ich? Wo bin ich ich? Und wo ist die Grenze zwischen Ich und Medienstar?«

Melhus' Arbeiten kreisen um die identitätsstiftende Kraft von Film und Fernsehen. Das Gefangensein im Medienzwang, die einstige »Sozialisierung als Sitztier« (Seifert), spitzt er auf die Frage zu, wie wir unser Ich in Zeiten medialer Manipulation überhaupt definieren. Bestimmt das Leben den medialen Alltag, oder werden wir durch die Medien physisch, sozial, emotional und kulturell bestimmt wie die Kinder, die heute in Pokémon-Bettwäsche aufwachen, aus Pokémon-Tassen trinken, Pokémon-T-Shirts tragen und in der Schule über die aktuelle Folge Pokémon im Fernsehen reden, um sich am Nachmittag zu Hause ganz ihrem Pokémon zu widmen.[3]

»Ich weiss nicht wer das ist« von 1991 ist Melhus' erstes Medienselbstporträt. Es besteht aus einzeln montierten Fernsehbildern und Tonfetzen, die die Identität der dargestellten Person monologisch umkreisen. In »Das Zauberglas«, ebenfalls aus dem Jahr 1991, setzt Melhus die zuvor begonnene Selbstbefragung deutlicher fort, indem er den Fernsehapparat ins Bild rückt und Teil einer nun dialogischen Szene werden lässt. Wie vor einem Spiegel sitzt ein Mann vor einem Fernsehapparat und rasiert sich den Kopf. Zwischen ihm und der auf dem Bildschirm erscheinenden Frau, die ebenfalls von Melhus verkörpert wird, entwickelt sich ein Gespräch, in dem es zum Beispiel heißt: »Ich rasiere mich.« – »Aber warum tust du das denn? Tut das nicht weh?« – »Ich war immer sehr einsam und allein.« – »Geh nicht weg, bleib bitte.« Weil sich die beiden Personen nicht erreichen und in sinnlosen Leerformeln aneinander vorbeisprechen, taumelt die Konversation kreisend ins Absurde.

Mit »Weit Weit Weg« drehte Melhus 1995 einen 39-minütigen 16-mm-Film, in dem er, wie in allen anderen Filmen auch, die Figuren selbst verkörpert. Hier ist es die einsame Dorothy. Bei der Suche nach einem Ausweg aus ihrem Kinder-Ich versucht Dorothy, sich mit Hilfe moderner Kommunikationssysteme ein Alter-Ego zu erschaffen, sich mit diesem auszutauschen und ihm zu begegnen. Das Vorhaben scheitert. Vergeblich fragt Dorothy immer wieder über ihr leuchtend gelbes Handy hilflos in den Äther, wer denn da sei, während sie sich selbst unablässig einer anonymen Außenwelt als »Dorothy« präsentiert. Melhus unterlegt dem Film Fragmente der weiblichen Synchronstimme aus The Wizard of Oz, 1939 gedreht von Victor Fleming. Zum Schluss zitiert Melhus die Originalstimme von Judy Garland und legt damit sich selbst die Worte einer Verstorbenen in den Mund: »Wundervoll, alles ist so wundervoll!« – »Ich heiße Dorothy, und wie geht es dir?« – »Danke, mir

geht es gut, und wie geht es dir?« – »Und wer bist du nun wirklich.« – »Ich weiss es nicht.«
– »Das ist ja entsetzlich.« – »Ich hatte die Masern im vorigen Jahr.« Auf unterschiedlichen
Bewusstseinsebenen führt der Dialog der beiden Personen aneinander vorbei. Am Ende
findet sich Dorothy in einer Art Cyberspace, wo sie ihrem Medien-Ich tausendfach, ent-
rückt wie ein Echo, begegnet. Auch diese Sequenz bildet einen in sich geschlossenen Kreis-
lauf mehrfach wiederholter originaler Satzfragmente aus vorgefundenem Filmmaterial
sowie Melhus' eigenen bildnerischen und sprachlichen Szenarien.

In »Again & Again (The Borderer)« spielt Melhus 1998 dann die künstliche Duplikation des
britischen Schafes »Dolly« in bewegten Bildern am eigenen Körper durch, wobei er Sub-
jekt und Objekt zugleich darstellt. Unmittelbare Bestätigung für seine Haltung zu der
Problematik einer möglichen biotechnischen Vervielfältigung des Menschen hat Melhus
in dem Aufsatz *Körperphantasien. Von Schafen und Menschen* von Joachim Kalka gefun-
den.[4] Hierin nimmt der Autor unter anderem Bezug auf eine satirische Erzählung, in der
von geschlechtslosen Wesen berichtet wird, die, nach Größe und Blattgestalt voneinander
unterschieden, wie Früchte auf Bäumen wachsen. Die reifen Früchte werden gepflückt und
in kochendes Wasser geworfen, aus dem alsbald die fertigen, nach gesellschaftlichem Stand
und beruflicher Funktion differenzierten Geschöpfe hervorspringen. In »Again & Again«
greift Melhus das Bild der geschlechtslosen Gestalt vor einem grünen Blatt als Motiv einer
rhythmisch gesteuerten Eigenreproduktion auf.

An anderer Stelle verweist Kalka auf ein altägyptisches Totenritual, bei dem den Ver-
storbenen bis zu 365 kleine Fayencefigürchen in Mumienform beigegeben wurden. Diese
sollten dem Toten als Doppelgänger im Jenseits zur Seite stehen und an seiner statt kör-
perliche Arbeiten des täglichen Bedarfs durchführen. Die fröhliche, geschlechtslose Selbst-
vervielfältigungsorgie in Melhus' Videoinstallation ist demnach kein Motiv, das erst durch
die modernen Errungenschaften technischer Genmanipulation zu Stande kommt. Viel-
mehr steht die Möglichkeit zur vielfachen Reproduktion des Menschen in einer alten Tra-
dition von Erzählungen und Riten. Als Soundtrack seines Videos hat Melhus Sequenzen von
Stimme und Musik aus einer amerikanischen Dauerwerbesendung für Schmuck bearbei-
tet, die er 1998 in einem Angebot für Homeshopping in Los Angeles gefunden hat. Musik
und Sprache erzeugen ein Gefühl der Leichtigkeit, die an ein Schlaraffenland denken lässt.

»Alle Texte sind natürlich Neukonstruktionen aus dem ursprünglich Gesagten. Bei ›Again
& Again‹ war es interessant, dass inmitten all der gesprochenen Wörter plötzlich das kleine
Wort ›kill‹ auftauchte, ohne einen weiteren Zusammenhang und erst bei wiederholtem

Hören wahrnehmbar. (Ich habe es immer als so etwas wie einen Schlachtruf auf dem Battlefield des Verkaufs gesehen.) Es steht nun in einem neuen Zusammenhang, als Teil der Zauberformel zu einem Ritual, in dem das Andere getötet, zugleich aber die Furcht vor seiner Auferstehung oder Doppelung geweckt wird.«[5]

Melhus geht es nicht darum, Medienphänome über das Bild zu beschreiben oder zu werten. Vielmehr arbeitet er mit dem unendlichen Fundus von Stimmen und Worten, wie sie in Klassikern des Films überlebt haben und Melhus' Fantasie wecken. Am Beginn jeder seiner Arbeiten steht das Aussuchen von Stimmen, die für ihn einen besonderen »Geruch« vermitteln und denen er nachspürt. Eine schier unerschöpfliche Quelle dafür sind die großen amerikanischen Filmarchive. Aus originalen Tonspuren kopiert Melhus umgangssprachliche Floskeln heraus, zumeist lapidare Texte, die er vervielfältigt, schneidet, neu abmischt und wiederholt. In seinen Videos reproduziert Melhus zum einen die gesprochene Medienrealität und entlarvt zugleich die Originaldialoge der Filmvorlage als Wortkompositionen ohne individuelle Aussage: »Am schönsten ist es doch daheim.« – »Ich heiße Dorothy, und wie heißt du?« – »Ihr seid die besten Freunde.« Für den Dialog zu »Das Zauberglas« hat Melhus Textfragmente aus dem US-Western *Broken Arrow* zusammengestellt, den Delmer Daves 1950 mit James Stewart gedreht hat.

Nachdem er abschließend den Soundtrack am Computer bearbeitet hat, zeichnet Melhus ein Storyboard für Aufbau, Anordnung und Aufnahme der Bilder, das als Grundlage für die eigentlichen Dreharbeiten dient. Mit oft einfachsten technischen Mitteln und unter zum Teil schwierigen Bedingungen dreht Bjørn Melhus seine komplexen und vielschichtigen Filme und Videos. Nicht selten muss der Künstler dabei ohne fremde Hilfe auskommen. So haben zum Beispiel die Astronauten in »Silvercity« (1999) immer wieder auf ihren Einsatz warten müssen, weil Melhus nicht zugleich vor und hinter der Kamera stehen und alle Abläufe synchron bewältigen konnte. Wiederholt hat sich die Kamera genau in dem Moment automatisch abgeschaltet, als Melhus noch dabei gewesen ist, sich für die Aufnahme vor einer Kulisse aus Styropor in Position zu bringen und sich selbst am Kopf zu verkabeln. Bei aller Perfektion der Produktionstechnik arbeitet Melhus mit profanen Mitteln der Simulation, um der »Wahrheit« gerecht zu werden.

Melhus' bisheriges Werk entspricht einer beständigen künstlerischen Selbstvergewisserung. Die Außenwelt liefert ihm beständig Identitätsmuster. Überall trifft Melhus auf Reproduktionsmechanismen von Körper, Sprache und Zeit. Körper, die reproduziert werden und ihre Individualität verlieren. Sprache, die reproduziert wird und ihre Bedeutung ver-

liert. Zeit, die nicht vergeht und im ewigen Kinderparadies stecken bleibt. Vor diesen Mustern befragt der Künstler sein eigenes Verhalten.

Die These, das Kunstwerk als Original habe durch optisch-technische Reproduktionsmittel seine Aura der Einzigartigkeit verloren, ist bereits 1936 von Walter Benjamin beschrieben worden.[6] Benjamins Ausführungen sind für Melhus' Werk von grundlegender Bedeutung. So wie die Fotografie einst angetreten war, das Erbe der realistisch-naturalistischen Malerei fortzuführen, hat das allanwesende Fernsehen inzwischen das Erleben der realen Welt ersetzt. Der Medienmensch, der als passives Wesen Welt genießt, läuft Gefahr, emotional zu erstarren, sich zu isolieren und eine gespaltene Wahrnehmung zu entwickeln. Das Subjekt gibt sich auf und wird selbst zum Imitat des Konsumierten. Authentizität ist fragwürdig geworden in einem Medium, das heute vor allem dazu da ist, Massenunterhaltung statt Erkenntnis zu bieten.

Das Fernsehen hat seit den 50er Jahren nicht nur unsere Wahrnehmung der Welt, sondern vor allem unsere Kommunikationsgewohnheiten erheblich verändert. Welt wird nicht mehr erzählt, erlesen und erlebt, sondern per Knopfdruck vom Fließband geholt. Während das Fenster nach draußen verdunkelt wird, eröffnet die Mattscheibe den Blick in die Ferne. Um etwas über die Welt zu erfahren, muss man ihr gleichsam den Rücken kehren. Privat wird man, wie Günther Anders festgehalten hat, zum »Massen-Eremiten«, zum »Heimarbeiter«, der in seinen Mußestunden einer ungewöhnlichen Arbeit nachgeht, nämlich der »Verwandlung seiner selbst in einen Massenmenschen«.

»Authentizität, wenn sie durch ständiges Wiederholen verfügbar gemacht wird und vom Individuum losgelöst ist, nimmt eine absurde und irreale Wirkung an. Dieser Eindruck, der zugleich ein Moment der Bedrohung enthält, wird durch die serielle Anordnung potenziert und bloßgelegt.«[7] So lautet eine Beschreibung einiger Arbeiten von Bruce Nauman, die wir unmittelbar auf Melhus' Versuch der Identitätssuche übertragen können: Wenn es auch Nauman – im Gegensatz zu Melhus – stets um den Körper des Individuums geht, führt er uns in seinen Installationen bewusst vor Augen, welche Konsequenz die Eliminierung von Kommunikation und Spiel hat. Das Empfinden eines autonomen, unantastbaren Selbst scheint unmöglich geworden.

»Das willkürliche Verfügen und Manipulieren des Menschen richtet sich gegen ihn selbst, der Mensch wird zu seinem eigenen Opfer.«[8] Wo Naumans Werk diese Erkenntnis durch die kreisförmige Anordnung vieler seiner Installationen unterstreicht, füllt Melhus seine

bildnerischen Erzählungen mit Satzwiederholungen an und komponiert auf diese Weise geschlossene Kreisläufe, die in sich selbst gefangen bleiben.

Bei Nauman geht es vorherrschend um das Erforschen von Körperbewusstsein, bei Melhus um die Beeinflussbarkeit des Ich und dessen Neudefinition durch die Massenmedien. Wie Nauman setzt auch Melhus hierfür den eigenen Körper ein. Rollenspiel und Aufführungscharakter nehmen bei Nauman clowneske, bei Melhus hingegen vorpubertäre Züge an. Während Nauman seine Geige auf die Töne D-A-E-D stimmte, verwendet Melhus für seine Dialoge tote Stimmen aus Filmen, die in den 30er oder 50er Jahren gedreht wurden. Kreismotive, simulatives Verhalten, der Hinweis auf den Tod, das alles sind Momente, in denen sich die Reflexionen des Jüngeren mit denen des Älteren treffen.

»Während die ewige Auseinandersetzung mit der Wahrheit sich um die Erscheinung von Wahrheit und um die Wahrheit selbst dreht, ist die Simulation die einzige Wahrheit, auf die wir uns verlassen können.«[9] Die Folge ist das Verschwinden des Subjekts. Auch die Pop-Art hat mit der Darstellung der Darstellung gearbeitet und damit ein sekundäres, nur mittelbares Verhältnis zur Realität aufgebaut.[10] Bjørn Melhus geht einen Schritt weiter, indem er visuelle und akustische Elemente auf unterschiedlichen Zeitebenen parallel laufen lässt. Auf der einen Seite sichert er dabei der von ihm aufgezeichneten Alltagssprache ein Überleben. Auf der anderen Seite hebt er seine nachgespielte Medienerfahrung aus der Erinnerung in die Gegenwart und bringt damit sich selbst ins Spiel ein. In seinen Filmen und Videos scheinen Mensch und Medium die Endlichkeit des Daseins in der Simulation für den Preis der Individualität endgültig hinter sich gelassen zu haben.

Katja Blomberg

1. Theodor W. Adorno, Résumé über Kulturindustrie (1963), wieder veröffentlicht in: Kursbuch Medienkultur, Die maßgeblichen Theorien von Brecht bis Baudrillard; hrsg. von Claus Pias, Joseph Vogl und Lorenz Egell, Stuttgart 1999, S. 202-208.

 Neil Postman, Das Zeitalter des Showbusiness (1985), wieder veröffentlicht in: Kursbuch Medienkultur, 1999, S. 223-233.

2. Günther Anders, Die Welt als Phantom und Matrize, Philosophische Betrachtungen über Rundfunk und Fernsehen (1956), wieder veröffentlicht in: Kursbuch Medienkultur, S. 209-222.

 John Fiske, Augenblicke des Fernsehens. Weder Text noch Publikum (1989), wieder veröffentlich in: Kursbuch Medienkultur, S. 234-253.

 Heribert Seifert, Verlorene Zeit, Was macht das Fernsehen mit dem Zuschauer?, in: Neue Zürcher Zeitung, Folio, Nr. 2, 2001, S. 18.

 Richard David Precht, Sieh mich, kauf mich, iß mich, in: Frankfurter Allgemeine Zeitung, 03.03.01, S. 46.

3. Precht, op. cit.

4. Joachim Kalka, Körperphantasien, Von Schafen und Menschen, in: Kursbuch 128, Lebensfragen, 1997, S. 1-14; vgl. S. 55-64 in diesem Buch.

5. Bjørn Melhus in einer E-Mail an die Verfasserin am 03.03.2001.

6. Walter Benjamin, Das Kunstwerk im Zeitalter seiner technischen Reproduzierbarkeit, in: Zeitschrift für Sozialforschung, Jg. 5, 1936 (Erstveröffentlichung in französischer Sprache).

7. Bruce Nauman, Image / Text 1966-1996, in: Kunstmuseum Wolfsburg, Gesammelte Werke 1, Zeitgenössische Kunst seit 1968 (Ausstellungskatalog), Ostfildern 1999, S. 338.

8. Nauman, op. cit.

9. Anthony Aziz und Sammy Cucher, Nachrichten aus Distopia, in: Kunstforum international, Die Zukunft des Körpers I, Bd. 132, Nov. 1995 / Jan. 1996, S. 172-175, Zitat S. 173.

10. Armin Zweite, Ich ist etwas Anderes, in: Ich ist etwas Anderes. Kunst am Ende des 20. Jahrhunderts, Global Art Rheinland; hrsg. von Armin Zweite, Doris Krystof und Reinhard Spieler, Köln 2000, S. 27-50, Zitat S. 35.

WE ARE DOUBLY IN OURSELVES

Michel de Montaigne, 1580

Works by Bjørn Melhus

The passion to replay media reality began at five. Bjørn Melhus played astronaut with his two-year-older sister in the family's living room. Shortly after the Apollo 11 moon landing, the two, under a woolen blanket, flew through the darkened outer space of their domestic environment. Occasionally they looked out at the earth, which stood in the corner of the room as a globe illuminated from within. Or they were the crew of *Star Trek*. Events transported by the media and film figures were replayed, along with *Bonanza* and *Fury*, which belonged to the everyday media life of children growing up in the late 1960s and early 1970s. The heroes of a media world that, in Germany, could still be taken in at a glance shaped the gestures, language, and fashions of a television generation that grew up under the spell of the monitor.

The phenomenon of the mediatization of society due to the inroads of television after World War II has been analyzed, from Theodor W. Adorno to Neil Postman.[1] From the 1950s until today, Günther Anders and John Fiske, Richard David Precht and Heribert Seifert have described the medium and its effect as a substitute for communication and experience.[2] In front of the TV monitor, the individual is transformed into the consumer of a mass commodity that hardly distinguishes anymore between entertainment and information, advertisement and image creation, truth and fiction. The mass medium that delivers »ready-to-consume meanings« (Fiske) to our living room around the clock and that »dry-cleans« us (Anders), i.e., presents reports fit for the media, has made it seemingly superfluous to experience the real world.

Melhus belongs to a generation that has constructed its identity in dialogue with the TV as a window to the world. For more than ten years, this artist has reflected on the medium by means of the medium. From these associative fragments, he cobbles together new fables and fairytales as media collages of his own images and borrowed voices. In videos, films, and installations, he grapples with his own media experience and asks:»Who am I? Where am I an I? And where is the boundary between the I and the media star?«

Melhus' works revolve around the identity-creating power of film and television. Captivity in the constraints of the media, the earlier »socialization as a sitting animal« (Seifert) – he brings this to a head in the question: How do we define our I at all in times of media manipulation? Does life rule over the everyday media world, or are we physically, socially, emotionally, and culturally determined by the media, like the children who now wake up in Pokémon sheets, drink from Pokémon cups, wear Pokémon T-shirts, talk at school about current television Pokémon episodes, and then, at home in the afternoon, devote themselves entirely to their Pokémon.[3]

»Ich weiss nicht wer das ist« (»I don't know who that is«), from 1991, was Melhus' first media self-portrait. It consists of individually mounted television images and snatches of sound that circle the identity of the depicted person in a monologue. In »Das Zauberglas« (The Magic Glass), also from 1991, Melhus continued the self-questioning he had begun earlier, now moving the television set into view and making it part of what was now a dialogical scene. A man sits in front of a television set as if in front of a mirror and shaves his head. A conversation develops between him and the woman appearing on the monitor, who is also played by Melhus, and we hear, for example: »I'm shaving myself.« – »Why would you do something like that? Doesn't it hurt?« – »I was always very lonely and alone.« – »Don't go away. Please stay.« Because the two persons do not reach each other and speak in meaningless empty formulas that pass by each other without meeting, the conversation wobbles and circles into absurdity.

In 1995, with »Weit Weit Weg« (»Far Far Away«), Melhus made a 39-minute 16-mm film in which, as in all his other films, he plays all the figures himself. Here it is the lonely Dorothy. Seeking a way out of her child I, Dorothy uses modern communications systems to try to create, communicate with, and encounter an alter ego. The attempt fails. In vain, Dorothy keeps broadcasting the question »Who's there?« through a bright yellow cell phone into the ether, constantly presented herself as »Dorothy« to an anonymous external world. Melhus underlays the film with fragments of the female dubbed voice from *The Wizard of Oz*, directed by Victor Fleming in 1939. At the end, Melhus quotes the original voice of Judy Garland, thus taking the words of a deceased person into his own mouth: »Wonderful, everything is so wonderful!« – »My name is Dorothy, and how are you?« – »Thank you, I'm fine, and how are you?« – »And who are you now really.« – »I don't know.« – »Why, that's terrible.« – »I had the measles last year.« On various levels of consciousness, the dialogue leads the two people away from each other. In the end, Dorothy finds herself in a kind of cyberspace where she encounters her media I a thousand-

fold, removed like an echo. This sequence, too, forms a closed cycle of often-repeated frag-
ments of original sentences from found film material, as well as from Melhus' own visual
and linguistic scenarios.

In 1998, in »Again & Again (The Borderer)«, Melhus played through the artificial duplication
of the British sheep »Dolly« in moving images on his own body, thereby representing sub-
ject and object at the same time. Melhus found indirect confirmation of his stance toward
the problematics of a possible biotechnological duplication of the individual in Joachim
Kalka's essay *Körperphantasien. Von Schafen und Menschen.*[4] The author refers to a satirical
story about sexless beings who grow like fruits on trees, distinguished by size and leaf
shape. The ripe fruits are plucked and thrown into boiling water, from which soon spring
finished beings, differentiated by social status and occupational function. In »Again &
Again«, Melhus takes up the image of the sexless figure in front of a green leaf as a motif
of a rhythmically controlled self-reproduction.

Elsewhere, Kalka refers to an ancient Egyptian ritual of death in which the deceased is
buried with up to 365 small faience figures in the form of mummies. These were supposed
to stand at the deceased's side as doppelgänger in the beyond and carry out the manual
labor of daily life in his place. The cheerful, sexless orgy of self-reproduction in Melhus'
video installation is thus a motif that arose long before the modern achievements of
technological genetic manipulation. Rather, the possibility of the multiple reproduction of
the individual stands in an old tradition of narratives and rites. To make the soundtrack of
his video, Melhus processed sequences of voice and music from an American endless-loop
broadcast, which he found advertising jewelry in a homeshopping offer in 1998 in Los
Angeles. Music and language create a feeling of lightness that recalls a Land of Cockaigne
or of »milk and honey«.

»All texts are, of course, new constructions out of what was originally said. In ›Again &
Again‹ it was interesting that, in the midst of all the spoken words, suddenly the little
word ›kill‹ surfaced, without any further context and perceptible only after several listen-
ings. (I have always regarded it as something like a battle cry on the battlefield of sales.)
Now it stands in a new context, as part of the magic formula in a ritual in which the other
is killed, but at the same time the fear of his resurrection or doubling is awakened.«[5]

Melhus is not concerned with describing or assigning values to media phenomena via the
image. Instead, he works with the endless stock of voices and words that have survived in

the classics of film and that spur his imagination. Each of his works begins with the selecting of voices that he feels convey a special »scent«, which he traces. He finds absolutely inexhaustible sources for this in the great American film archives. From original soundtracks, Melhus copies colloquial phrases, usually terse texts that he duplicates, cuts, remixes, and repeats. In his videos, Melhus reproduces the spoken media reality and, at the same time, exposes the original dialogues of the given film as word compositions without any individual message: »There's no place like home.« – »My name is Dorothy, and what's your name?« – »You are the best friends.« For the dialogue in »Das Zauberglas«, Melhus collaged text fragments from the American Western *Broken Arrow*, which Delmer Daves directed with James Stewart in 1950.

After finishing the soundtrack by processing it on the computer, Melhus draws a storyboard for the composition, arrangement, and shooting of the images; it serves as the basis for the actual filming. Often with the simplest technical means and sometimes under difficult conditions, Bjørn Melhus shoots his complex and many-layered films and videos. Often the artist must make do without help from anyone else. For example, the astronauts in »Silvercity« (1999) always had to wait to go into action because Melhus could not stand in front of and behind the camera at the same time and manage all the procedures at one and the same time. More than once, the camera shut off automatically at a moment when Melhus was still just getting into position for a shot in front of a backdrop of styrofoam and plugging in the connections on his head. Despite all the perfection of production technology, Melhus works with profane means of simulation to do justice to the »truth«.

Melhus' work so far corresponds to a constant artistic self-exploration. The external world constantly provides him with patterns of identity. Everywhere, Melhus encounters the reproductive mechanisms of body, language, and time. Bodies that are duplicated and lose their individuality. Language that is duplicated and loses its meaning. Time that does not pass, but remains stuck in an eternal child's paradise. In the face of these patterns, the artists questions his own behavior.

In 1936, Walter Benjamin already extensively elaborated the hypothesis that the work of art, as original, has lost its aura of uniqueness due to the optical-technical means of reproduction.[6] Benjamin's elucidations are of fundamental importance for Melhus' work. Just as photography once stepped in to continue the legacy of realistic-naturalistic painting, the omnipresent television has meanwhile replaced the experience of the real world.

The media person who enjoys the world as a passive being runs the dangers of emotionally petrifying, of isolating himself, and of developing a split perception. The subject gives itself up and becomes an imitation of what it consumes. Authenticity has become questionable in a medium whose purpose today is above all to offer mass entertainment, rather than knowledge.

Since the 1950s, television has substantially changed not only our perception of the world, but also and above all our habits of communication. The world is no longer narrated, read, and experienced, but fetched from the assembly line by pushing a button. While the window to the outside is darkened, the monitor opens the glance into the distance. It is as if one had to turn one's back on the world to experience something about it. As Günther Anders noted, one privately becomes a »mass hermit«, a »home worker« who uses his leisure hours to perform an unusual labor, namely »transforming himself into a mass man«.

» Authenticity, if it is made controllable through constant repetition and separated from the individual, takes on an absurd and unreal effect. This impression, which simultaneously contains an element of threat, is potentiated and exposed by the serial arrangement.«[7] This description of some works by Bruce Nauman could be directly applied to Melhus' attempt to seek identity: If Nauman, unlike Melhus, is always concerned with the individual's body, in his installations he consciously shows us the consequences entailed by the elimination of communication and play. It seems to have become impossible to feel like an autonomous, inviolable self.

»The arbitrary control and manipulation of the individual is directed against him himself; the individual turns into his own victim.«[8] Where the circular arrangement of many of Nauman's installations underscores this recognition, Melhus fills his visual narratives with repetitions of sentences and in this way composes closed cycles that remain captive in themselves.

Nauman is primarily concerned with exploring bodily awareness; Melhus is interested in the influencibility of the I and its redefinition through the mass media. Like Nauman, Melhus uses his own body to do this. Role-playing and performance are clownish in Nauman's work; in Melhus', by contrast, they take on pre-adolescent traits. Nauman tuned his violin to the tones D-A-E-D; for his dialogues, Melhus used dead voices from films shot in the 1930s or 1950s. Circle motifs, simulative behavior, the reference to death, all these are elements in which the reflections of the younger artist intersect with those of the older.

»While the eternal wrestling with truth focuses on the appearance of truth and on truth itself, the simulation is the only truth we can rely upon.«[9] The result is the disappearance of the subject.[10] Pop Art, too, worked with the depiction of the depiction, and thus built up a secondary, merely indirect relationship to reality. Bjørn Melhus goes one step further by letting visual and acoustic elements run parallel on different levels of time. On the one hand, he thus secures the survival of the everyday speech he has recorded. On the other hand, he elevates the media experience he replays out of memory and into the present, thus bringing himself into play. In his films and videos, individual and medium seem, in simulation, to have left the finiteness of existence behind them forever – at the price of their individuality.

Katja Blomberg

1. Theodor W. Adorno, Résumé über Kulturindustrie (1963), republished in: Kursbuch Medienkultur, Die maßgebliche Theorien von Brecht bis Baudrillard; ed. Claus Pias, Joseph Vogl, Lorenz Egell, Stuttgart 1999, p. 202-208.
 Neil Postman, Das Zeitalter des Showbusiness (1985), republished in: Kursbuch Medienkultur, 1999, p. 223-233.

2. Günther Anders, Die Welt als Phantom und Matrize, Philosophische Betrachtungen über Rundfunk und Fernsehen (1956), republished in: Kursbuch Medienkultur, p. 209-222.
 John Fiske, Augenblicke des Fernsehens. Weder Text noch Publikum (1989), republished in: Kursbuch Medienkultur, p. 234-253.
 Heribert Seifert, Verlorene Zeit, Was macht das Fernsehen mit dem Zuschauer?, in: Neue Zürcher Zeitung, Folio, Nr. 2, 2001, p. 18.
 Richard David Precht, Sieh mich, kauf mich, iß mich, in: Frankfurter Allgemeine Zeitung, March 3, 2001, p. 46.

3. Precht, op. cit.

4. Joachim Kalka, Körperphantasien, Von Schafen und Menschen, in: Kursbuch 128, Lebensfragen, 1997, p. 1-14; compare p. 67-75 in this book.

5. Bjørn Melhus in an Email to the author on March 3, 2001.

6. Walter Benjamin, Das Kunstwerk im Zeitalter seiner technischen Reproduzierbarkeit, in: Zeitschrift für Sozialforschung, Year 5, 1936 (first published in French).

7. Bruce Nauman, Image / Text 1966-1996, in: Kunstmuseum Wolfsburg, Gesammelte Werke I, Zeitgenössische Kunst seit 1968 (exhibition catalog), Ostfildern 1999, p. 338.

8. Naumann, op. cit.

9. Anthony Aziz and Sammy Cucher, Nachrichten aus Distopia, in: Kunstforum international, Die Zukunft des Körpers I, Vol. 132, Nov. 1995 / Jan. 1996, p. 172-175, quotation p. 173.

10. Armin Zweite, Ich ist etwas Anderes, in: Ich ist etwas Anderes. Kunst am Ende des 20. Jahrhunderts, Global Art Rheinland 2000; ed. Armin Zweite, Doris Krystof, and Reinhard Spieler, Cologne 2000, p. 27-50, quotation p. 35.

BIOGRAFIE / BIOGRAPHY

1966 geboren in / born in Kirchheim / Teck, Deutschland / Germany

1985-86 Filmschule / Film Academy Stuttgart

1985-87 Adolf-Lazi-Schule Stuttgart (Berufsfachschule f. Fotografie und Audiovision / technical college for photography and audiovision)

1988-90 Freiberufliche Tätigkeit als AV-Designer / freelance audiovisual designer in Berlin

1988-96 Studium der Freien Kunst an der HBK Braunschweig / studied fine arts at Braunschweig School of Arts (Film, Video)

1996 EMARE-Programm / Program, Budapest (European Media Artists in Residence Exchange)

1996-97 Aufbaustudium, Meisterschüler bei / advanced study, master student with Prof. Birgit Hein, HBK Braunschweig / Braunschweig School of Arts

1997-98 DAAD-Jahresstipendium / German Academic Service Abroad year stipend, Los Angeles (California Institute of the Arts)

1998 Förderstipendium des Braunschweigischen Vereinigten Kloster- und Studienfonds / Support Stipend of the Braunschweig United Cloister and Study Fund

1999 Gastlehrauftrag für Video an der / Guest Lecturer for Video at the Bauhaus-Universität Weimar

1999 / 2000 Preis des / Prize of the Kunstverein Hannover (Atelierstipendium / studio stipend)

2001 / 2002 New-York-Stipendium des Landes Niedersachsen (International Studio and Curatorial Program ISCP) / New York stipend of the State of Lower Saxony (International Studio and Curatorial Program ISCP)

**Preise und Auszeichnungen (Auswahl) /
Prizes and Awards (Selection)**

1992 Nachwuchspreis Videofest Berlin /
Young Artists Award Videofest Berlin,
»Das Zauberglas« (The Magic Glass); Sonderpreis
des Marler Videokunstpreises / Special Prize of
the Marl Video Art Prize, Marl, »Das Zauberglas«
(The Magic Glass); Bremer Videokunst-
Förderpreis / Video Art Award, OdEssay
video mail

1993 Eric-Wynalda-Techno-Award,
Filmwinter Stuttgart, »Das Zauberglas«
(The Magic Glass)

1994 KUBO-Kunstpreis / Art Award, Bremen,
»Das Zauberglas« (The Magic Glass)

1998 8. Marler Videokunstpreis /
8th Video Art Prize, Marl, »No Sunshine«;
Prix Elida-Fabergé 1. Preis / 1st Prize,
München / Munich, »No Sunshine«;
2. Preis / 2nd Prize, Transmediale Berlin,
»No Sunshine«;
Preis der Deutschen Filmkritik / Award
of the German Filmcritics, European
Media Art Festival, Osnabrück, »No Sunshine«;

Bjørn Melhus 1971 Apollo 11

Förderpreis Film des Landes
Niedersachsen 1998 / Prize Film
of the State of Lower Saxony 1998;
Certificate of Merit, San Francisco
International Film Festival, »No Sunshine«;
New Visions Video, Long Beach Museum of Art
(Production Grant)

2000 Auszeichnung durch den
Internationalen Kunstkritikerverband
(Deutschland) für die Einzelausstellung
»Gute Freunde«, Museum Schloss Hardenberg,
Velbert / Honor by the International Art Critics
Association (Germany) for the solo
exhibition »Gute Freunde« (Good Friends),
Museum Schloss Hardenberg, Velbert

Einzelausstellungen / Solo Exhibitions

1999 »ich bin du« (me is you),
Skulpturenmuseum Glaskasten, Marl;
»Primetime vol. 1«, Galerie Anita Beckers,
Frankfurt

2000 »Again & Again (The Borderer)«,
Galerie Birner & Wittmann, Nürnberg;
»Gute Freunde« (Good Friends),
Museum Schloss Hardenberg, Velbert,
Kunstverein Wolfenbüttel

2001 »Limboland«, (Film-Video-Retrospektive
1998-1999) unter anderem / selection:
Goethe Institut Los Angeles; Goethe Institut
Toronto; VOID New York; Aurora Picture Show,
Houston; Ritz, Austin; Kommunales Kino Freiburg,
Stuttgart, Karlsruhe; Cinemayance Mainz; Babylon
Berlin; Caligari Wiesbaden; Lichtmess Hamburg;
»du bist nicht allein – you are not alone«,
Stadtgalerie Saarbrücken; Kunsthalle Göppingen;
»Primetime«, Kunstverein Hannover;

Ausstellungsbeteiligungen (Auswahl) / Group Exhibitions (Selection)

1991 ... alles wandelt sich,
Videokünstler zur Wiedervereinigung /
Video Artists on Reunification,
Kölnischer Kunstverein

1990-1992 Deutsche Video-Kunst,
Wanderausstellung zum 5. Marler Video-
Kunstpreis / traveling exhibition with
the 5th Video Art Prize, Marl

1991-1994 Deutsche Video-Kunst,
Wanderausstellung zum 6. Marler
Video-Kunstpreis / traveling exhibition
with the 6th Video Art Prize, Marl

1992/1996 77./79. Herbstausstellung /
Autumn Exhibition, Kunstverein Hannover

1993 MEDIALE, Kunsthalle Hamburg

1994 x'94, Akademie der Künste / Academy
of Arts, Berlin, Videoketten / Video Chains

1996 Gesellschaft für Aktuelle Kunst /
Society for Contemporary Art, Bremen,
»OdEssay«

1996 German Video Art, Metropolitan
Museum of Contemporary Photography,
Tokio / Tokyo

1997 Goethe-Institut, Budapest, »Epreskert
(Strawberry Garden)« in Zusammenarbeit mit /
in cooperation with Julia Neuenhausen

1998 New Visions Video, Long Beach
Museum of Art, Long Beach

1998-1999 8. Marler Video-Kunstpreis /
8th Video Art Prize, Marl (Wanderausstellung /
traveling exhibition), Neuer Berliner Kunstverein /
New Berlin Art Association; Video-Forum Blue Box,
Wiesbaden; Neues Museum / New Museum
Weserburg, Bremen; Kunstverein Braunschweig

1999 Ein Treppenhaus für die Kunst IV/
A Staircase for Art IV, Niedersächsisches
Ministerium für Wissenschaft und Kultur /
Lower Saxony Ministry for Science and Culture,
Hannover
ideal, Luzerner Ausstellungsraum / Lucerne
Exhibition Room, Vierwaldstättersee
Kunstpreis der Böttcherstraße in Bremen /
Böttcher Street Art Prize in Bremen, Kunsthalle
Bremen
Lokalzeit / Local Time, Kunstverein Hannover
Das Lachen des Ovid / Ovid's Smile, Galerie / Gallery
Voges + Deisen, Frankfurt
From B to A ... and back, Arti et Amicitiae,
Amsterdam; Artmax, Braunschweig
Come in and find out, vol.1, Podewil, Berlin
48. Kunst-Biennale /48th Art Biannual, Venedig,
Beitrag der Videolounge von / Contribution of the
Video Lounge by Costa Vece & Patrick Huber,
Arsenale Corderie
Video Virtuale - Foto Fictionale / Virtual Video -
Fictional Photo, Museum Ludwig, Köln
Körperinszenierungen, Oper Frankfurt /
Frankfurt Opera
From B to A and further, Artmax,
Braunschweig

2000 reality checkpoint - körperszenarien / body
scenarios, Edith-Ruß-Haus, Oldenburg

Dive in, Kunstpanorama Luzern /
Art Panorama Lucerne
// fresh, EMAF, Osnabrück
Kennen wir uns /
Do We Know Each Other,
Kunsthalle Nürnberg
Almost Done, Stiftung Starke /
Starke Foundation, Berlin
Times are changing / Auf dem Wege!,
Kunsthalle Bremen, Auswahl der Sammlung /
selected pieces of the collection

Festivals (Auswahl / Selection)

1988 / 1992 / 1995 / 1998 / 2000
European Media Art Festival,
Osnabrück

1990 / 1992 / 1996 / 1997
Videofest Kassel

1991 / 1993 / 1994 / 1996 / 1998
Stuttgarter Filmwinter

1992 / 1998
Internationale Kurzfilmtage /
International Short Film Days
Oberhausen; VIDEOFEST,
Transmediale Berlin

1996
VIENNALE, Internationale Filmfestwochen Wien /
International Film Festival Vienna

1998
San Francisco International Film Festival;
World Wide Video, Amsterdam; Pandæmonium,
London; Festival for New Cinema and
New Media, Montréal

Auto Center Drive (Dreharbeiten / Shooting 2001)

WERKVERZEICHNIS / CATALOGUE OF THE WORKS

America Sells 1990

Jetzt 1993

Toast
1986, 16 mm film, 1 min,
Written, directed, and edited in
collaboration with Anne Maar,
performed by Anne Maar.

Cornflakes
1987, 16 mm film, 2 min,
Performed by Ludger Haninger
and Friedhelm Backhaus, sound in
collaboration with Peter Ziegelmeier.

Nicht werfen! (Do not throw!)
1988, installation and video, 16 min loop,
performed by Peter Ziegelmeier.

America Sells
1990, video, 7 min.

Ich weiss nicht wer das ist
(I don't know who that is),
1991, video, 3 min.

Das Zauberglas
(The Magic Glass),
1991, video, 6 min,
stylist: Julia Neuenhausen,
additional camera operator:
Oliver Becker.

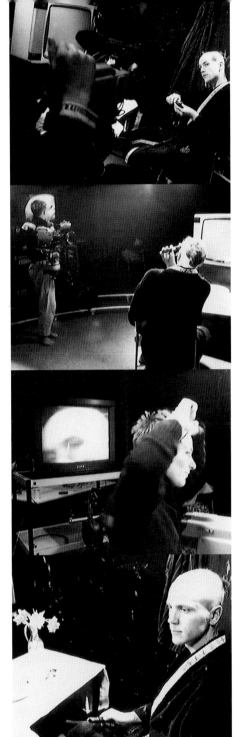

Das Zauberglas (Dreharbeiten / Shooting 1991)

Jetzt (Now)
1993, video, 5 min.

Reinigungscassette
(Cleaning Tape)
1993, video, 60 min.

OdEssay Video Mail
1994, Worldwide video chain
letter / installation.

Weit Weit Weg (Far Far Away)
1995, 16 mm film, 39 min,
director of photography:
Edward Berger, assistance:
Andreas Doub, Florian Hoffmeister,
stylist: Julia Neuenhausen,
costume designed by Astrid Maier,
music: Tilmann Dehnhard,
digital sound mix: Sascha Starke,
assistant director: Christoph Girardet,
supported by: Film- und Videoklasse,
HBK Braunschweig, Institut für
Medienwissenschaft und Film,
HBK Braunschweig,
Elektronisches Studio, TU Berlin,
Werkleitz Gesellschaft e. V., gefördert
mit Mitteln des Landes Niedersachsen
(Film Funding Lower Saxony).

Weit Weit Weg (Dreharbeiten / Shooting 1994)

Von links nach rechts / from left to right:

Florian Hoffmeister, Julia Neuenhausen,

Bjørn Melhus, Edward Berger, Christoph Girardet

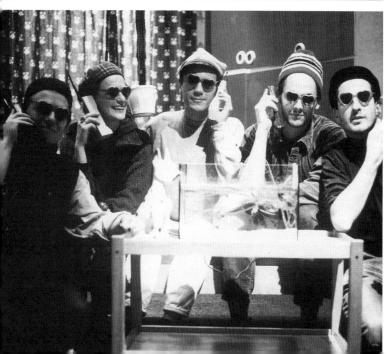

Home I 1996

Epreskert (Video 1997)

Home I
1996, video sculpture,
8 min loop, (In collaboration
with Ole Johan Melhus).

Epreskert
(Strawberry Garden)
1996, installation and video, 4 min 30 s loop,
realized at the EMARE residency
in Budapest in collaboration
with Julia Neuenhausen.

No Sunshine
1997, single-channel video, 6 min,
installation on two video cubes,
6 min loop, performed by Bjørn and
Roald Melhus, director of photography:
Christoph Girardet, stylist: Julia
Neuenhausen, cgi: Mike Orthwein,
sound: Sascha Starke,
postproduction at Werkleitz
Gesellschaft e.V., supported by: Film-
und Videoklasse, HBK Braunschweig,
Institut für Medienwissenschaft
und Film, HBK Braunschweig,
FH Hannover, Elektronisches Studio,
TU Berlin, Niedersächsisches
Ministerium für Wissenschaft und
Kultur (Film Funding Lower Saxony).

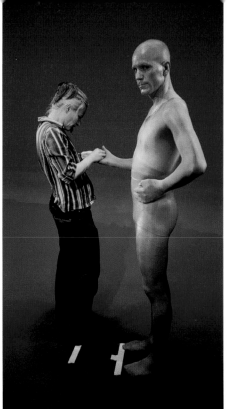

No Sunshine (Dreharbeiten / Shooting 1997)

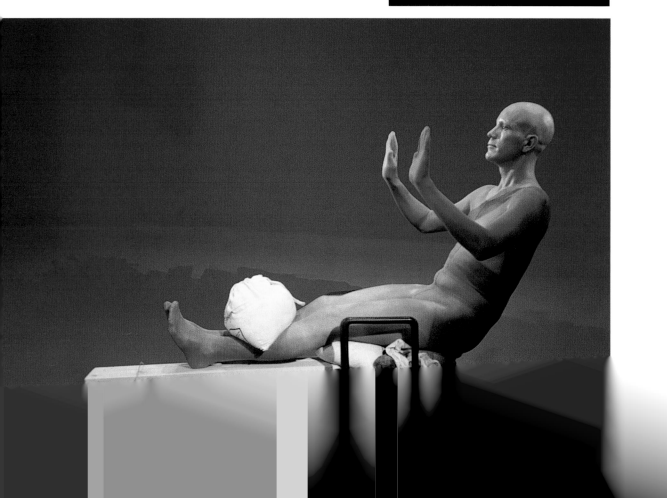

Blue Moon
1997/1998, single-channel video,
4 min, double-channel video,
installation 4 min loop
(Additional camera operator
Sabine Nolden).

Out of the Blue
1997/1998,
video, 4 min.

Again & Again (The Borderer)
1998, video for installation on
8 monitors, production crew:
Mariela Cadiz, Johnny Gho,
John Hawk, Gordon Kurowski,
Damon McCarthy, Esther Mera,
Allessandro Mercuri,
Joseph Merrell, Francesca
N. Penzani, Jesse Stout,
supervisor: Janice Tanaka,
sound mix: Niels Müller,
shot at the California Institute
of the Arts, postproduction at
Cross Rhodes Production,
Los Angeles, produced in part
by the Long Beach Museum
of Art New Visions
Video Grant.

Arrival – Departure
1998, video for installation,
7 min loop.

Arrival – Departure
1998, computer installation /
2 LED cubes (In collaboration
with Ole Johan Melhus).

Silvercity 1
Silvercity ist weit weg
(Silvercity is far away),
1999, video for installation, 7 min.

Silvercity 2
The End of the Beginning, 1999,
video for installation, 7 min.

Good Morning New World
2000, video, 58 min, compilation
of 75 TV excerpts of the
New Years 2000 spectacle.

Auto Center Drive
2001, 16 mm film, 20 min,
director of photography: Michael Jarmon,
camera assistant: Jesse Stout,
still photography: Ralf Henning,
production assistant: T. Paul Gleason.

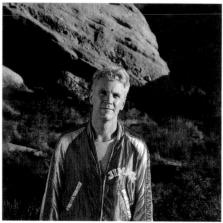

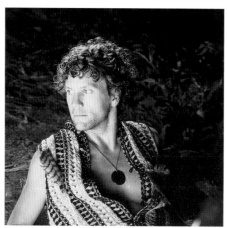

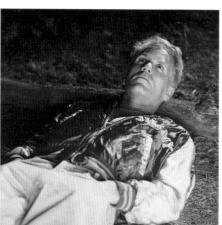

Auto Center Drive (Dreharbeiten / Shooting 2001)

BIBLIOGRAFIE / BIBLIOGRAPHY

Bjørn Melhus, LISTEN, in:
below papers 3, Virale Praxis, vol.1,
Hg. / ed. Thomas Wulffen,
Berlin 1994, S. / p. 264 ff.

Bjørn Melhus, nur Text 1990-1997,
Textbuch zu Filmen und Videos
anlässlich der Ausstellung
Meisterschüler 97 / book with text
on films and videos accompanying
the Master Student Exhibition 97,
Eigenverlag / self-published,
Braunschweig 1997.

Nina Schulze, Ich bin Du –
Bjørn Melhus und die Anderen,
Konstellationen und Konstruktionen
von Identität, in: Kölner Museums-Bulletin
4 / 1999, S. / p. 49-58.

Bjørn Melhus, Ich bin Du,
Videocassette als Katalog /
video cassette as catalogue,
Preisträger des 8. Marler Video-
Kunst-Preises / winner of the 8th Marl
Video Art Prize, Ausschnitte, Dokumentation
und Interview, / excerpts, documentation,
and interview, Skulpturenmuseum
Glaskasten, Marl 1999.

Gislind Nabakowski, in:
Katalog / catalogue
»Kunstpreis der Böttcherstraße
in Bremen 1999«, Kunsthalle
Bremen 1999, S. / p. 20-25.

Yvonne Volkart, Phantasmen
der Reproduktion, Ein Treppenhaus
für die Kunst IV, in: Ausstellungs-
dokumentation, Niedersächsisches
Ministerium für Wissenschaft
und Kultur, Hannover 1999.

Alice A. Kuzniar, The Queer German
Cinema, in: Stanford University Press,
Stanford 2000, S. / p. 194.

AUTOREN / AUTHORS

Katja Blomberg, geb. 1956 in Hamburg, Studium der Kunstgeschichte, Klassischen Archäologie und Neueren Deutschen Literaturwissenschaften in Freiburg / Br., 1981 Magister Artium in Hamburg, 1992 Promotion in Heidelberg (Tendenzen der Abstraktion in der deutschen Plastik der Nachkriegszeit). Seit 1992 ständige freie Mitarbeiterin im Feuilleton der Frankfurter Allgemeinen Zeitung; freie Kuratorin; Redakteurin der FAZ.Net online-Redaktion; zahlreiche Publikationen zur Kunst nach 1945.

Katja Blomberg, born in Hamburg in 1956. Studied Art History, Classical Archeology, and Recent German Literature in Freiburg / Br. Master of Arts, 1981, in Hamburg; Doctorate, 1992, in Heidelberg (Tendencies of Abstraction in German Postwar Sculpture). Since 1992, Katja Blomberg has been a regular freelance contributor to the feuilleton of the Frankfurter Allgemeine Zeitung and a freelance curator; member of the FAZ.Net online editorial staff. She has numerous publications on art after 1945.

Joachim Kalka, 1948 in Stuttgart geboren, ist Übersetzer und Kritiker und schreibt für die Frankfurter Allgemeine Zeitung und die Neue Zürcher Zeitung sowie für Zeitschriften wie Kursbuch, Schreibheft oder Neue Rundschau. Er hat etwa achtzig Bücher übersetzt, überwiegend aus dem Englischen und Amerikanischen, gelegentlich aus dem Französischen. 1996 erhielt er den Johann-Heinrich-Voß-Preis der Deutschen Akademie für Sprache und Dichtung, zu deren Mitglied er 1997 gewählt worden ist.

Joachim Kalka was born in Stuttgart in 1948. He is a translator and critic and writes for the Frankfurter Allgemeine Zeitung, the Neue Zürcher Zeitung, Kursbuch, Schreibheft, and Neue Rundschau. He has translated some eighty books into German, mostly from English and occasionally from French. In 1996, he received the Johann Heinrich Voß Prize for language and poetry from the Deutsche Akademie. In 1997, he was voted a member of the same body.

Werner Meyer, geboren 1953, studierte 1972-1975 an der Pädagogischen Hochschule Reutlingen (Deutsch und Kunsterziehung) und 1977-1983 an den Universitäten in Tübingen und Paris (Kunstgeschichte, Empirische Kulturwissenschaften, Philosophie). 1984-1985 Staatsgalerie Stuttgart (Volontariat), 1986-1988 Leiter der Hans Thoma-Gesellschaft / Kunstverein Reutlingen, seit 1989 Direktor der Kunsthalle Göppingen. Zahlreiche Publikationen zur zeitgenössischen Kunst sowie auch frei kuratierte Ausstellungen und Projekte.

Werner Meyer, born in 1953, studied German and Art Pedagogy from 1972 to 1975 at the Pädagogische Hochschule (Pedagogical College) Reutlingen and Art History, Empirical Cultural Studies, and Philosophy from 1977 to 1983 at the universities in Tübingen and Paris. 1984-1985 Staatsgalerie Stuttgart (internship); 1986-1988 Director of the Hans-Thoma-Gesellschaft / Kunstverein Reutlingen; since 1989, Director of the Kunsthalle Göppingen. Werner Meyer has published extensively on contemporary art. He works as a freelance curator for exhibitions and projects.

Bernd Schulz, geboren 1941, arbeitete nach naturwissenschaftlichem Studium in Freiburg / Br. als Kultur- und Wissenschaftsjournalist (u. a. Leitung des Ressorts Kultur und Wissenschaft beim Saarländischen Rundfunk), seit 1984 Aufbau und Leitung der Stadtgalerie Saarbrücken. Honorarprofessor für Kunst und Wissenschaft an der Hochschule der Bildenden Künste Saar, Saarbrücken.

Bernd Schulz was born in 1941. After studying natural sciences in Freiburg / Br. he worked as a journalist in the fields of culture and science (Manager of the Department for Culture and Science at Radio Saarland). Since 1984, he has built up and headed the Stadtgalerie Saarbrücken. He is an Honorary Professor of Art and Science at the Saarland College of Visual Arts in Saarbrücken.

© 2001
Kehrer Verlag Heidelberg, Bjørn Melhus,
Autoren und Fotografen / Authors and
Photographers

Herausgeber / Editor: Bernd Schulz

Redaktion / Copy Editing:
Berthold Schmitt , Bernd Schulz

Redaktionelle Mitarbeit / Editorial Staff:
Irmgard Heesche

Sekretariat / Secretary: Lydia Tebroke-Klammt

Texte / Texts: Katja Blomberg, Joachim Kalka,
Bjørn Melhus, Werner Meyer, Bernd Schulz

Fotos / Photos: Christoph Girardet,
Tom Gundelwein, Ralf Henning, Bjørn Melhus,
Ole Johan Melhus, Julia Neuenhausen,
Judith Nopper

Übersetzungen / Translations:
Mitch Cohen, Joachim Kalka

Lektorat / Editorial: Irmgard Heesche

Gestaltung und Herstellung /
Design and production: Kehrer *com* Heidelberg

CD-ROM Gestaltung / Design: Till Cremer

CD-ROM Mastering: Christian Deutsch
in Kooperation mit der Hochschule
der Bildenden Künste Saar

Ausstellung / Exhibition:
Stadtgalerie Saarbrücken in der
Stiftung Saarländischer Kulturbesitz,
St. Johanner Markt 24, D – 66111 Saarbrücken
in Kooperation mit der / in cooperation with
the Hochschule der Bildenden Künste Saar
(17.02.–25.03.2001)

Kunsthalle Göppingen, Marstallstraße 55,
D–73033 Göppingen (01.04.–13.05.2001)

Für die freundliche Unterstützung danken
wir / For their kind support our thanks to:
Galerie Anita Beckers, Frankfurt/Main
Galerie Birner + Wittmann, Nürnberg

Die Deutsche Bibliothek –
CIP-Einheitsaufnahme:
Bjørn Melhus, Du bist nicht allein =
Bjørn Melhus, you are not alone /
[Ausstellung: Stadtgalerie Saarbrücken in
der Stiftung Saarländischer Kulturbesitz,
Saarbrücken ; Kunsthalle Göppingen. In
Kooperation mit der Hochschule der Bildenden
Künste Saar]. Bjørn Melhus. Hrsg. von Bernd
Schulz. Mit Beitr. von Katja Blomberg ...
[Übers.: Mitch Cohen ; Joachim Kalka]. -
Heidelberg : Kehrer , 2001

ISBN 3-933 257-55-7
Kehrer Verlag Heidelberg (Buchhandelsausgabe)

ISBN 3–932 183–25–8
Stadtgalerie Saarbrücken (Ausstellungsausgabe)